CROMER
THROUGH TIME
Hugh Madgin

AMBERLEY PUBLISHING

Acknowledgements

The production of this book has been greatly assisted by David and Mandy Cornell and Wilf Neilson. To them I would like to record my grateful thanks. Special thanks are also due to my wife Cath for her unfailing support.

Hugh Madgin
2011

Hugh Madgin has been fascinated by the history for Cromer for years. He is the creator of cromeronthenet.com.

First published 2011

Amberley Publishing
The Hill, Stroud
Gloucestershire, GL5 4EP

www.amberley-books.com

Copyright © Hugh Madgin, 2011

The right of Hugh Madgin to be identified as the Author of this work has been asserted in accordance with the Copyrights, Designs and Patents Act 1988.

ISBN 978 1 4456 0676 7

British Library Cataloguing in Publication Data. A catalogue record for this book is available from the British Library.

Typeset in 9.5pt on 12pt Celeste.
Typesetting by Amberley Publishing.
Printed in the UK.

Introduction

With its medieval origins as a replacement for the thriving port of Shipden, which was lost to the sea, Cromer has a long and interesting history. Shipden fell prey to the sea in the 1300s and, if the magnificent church of St Peter & St Paul is any reliable indicator, Cromer grew up as a very prosperous town in the next couple of centuries. The seventeenth and eighteenth centuries appear to have been a period when the fortunes of Cromer waned somewhat, but since the latter part of the eighteenth century, Cromer has been almost continuously on an upward trajectory.

It was in 1785 that the town first came to be visited as a resort. It developed modestly for the next hundred years, and when first one railway line, from Norwich, and then a second from the East Midlands, arrived in the town, its prosperity accelerated rapidly. The town experienced a great rebuilding from the 1880s (again, the fortunes of the church reflected those of the town at large, with the building experiencing a refurbishment so urgently required that it could best be described as a rescue).

While the railway age ended Cromer's maritime trade, except for its fishing, the town benefited from what can only be described as boom years. Hotels and villas of great architectural quality sprang up around the town and in the 1890s, when the sale of a large parcel of the Cromer Hall estate prompted more new building on a large scale, the town expanded westwards.

However, while great new developments were taking place, the town never erased its history. The new was added to the old, and the wide, straight terraces and avenues complemented rather than replaced the heart of the old town. The popularisation of this part of the Norfolk coastline as 'Poppyland' through the writings of Clement Scott in the late nineteenth century was a worthy reflection of the area's attractiveness.

The situation of Cromer, on cliffs 60 feet above the sea, surrounded by what are for Norfolk vertiginous well-wooded hills, accounts for much of its great charm. However, it is the way in which the past 130 years of development have enriched rather than destroyed what was already there, which cements the town's appeal as one of the finest seaside resorts anywhere.

Cromer suffered badly during the Second World War; it is the closest part of England to Germany and was just 16½ minutes flying time from the nearest German airfield, resulting in a great deal of bomb damage. By 1942, seven out of its eight principal hotels were closed and in military use and it had become virtually a garrison town. Recovery after the war did come, but some of the great hotels, such as the Metropole and the Marlborough House never did reopen.

In recent years, Cromer has gained recognition for the things it does so well, which other places seem to have forgotten how to do. It is no coincidence that Cromer has the very last pier-end variety show and one of the most thriving independent cinemas in the country. In the early twenty-first century, Cromer is back firmly on that upward trajectory.

The story of Cromer features a galaxy of the great and the good over the centuries, from Sir Thomas Fowell Buxton to Winston Churchill and Albert Einstein to Sir James Dyson; indeed its literary, artistic and political connections seem to be almost endless. Pride of place, however, must go to a deck chair and beach hut proprietor; the inspirational Henry Blogg. His story and that of the Cromer lifeboats is barely touched upon in these pages – it is ably covered in detail elsewhere – but the story of the man whose memorial inscription is spot on as 'one of the bravest men who ever lived', will warm the coldest heart.

The same, in a more diffuse way, is true of Cromer itself. As the lady in the bar of the Dolphin Hotel said after the last photographs for this book had been taken, 'once I'd been here the first time, I just couldn't stop coming back'.

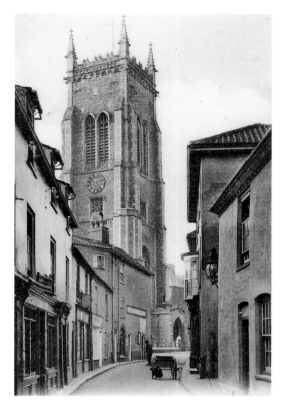

Church and High Street

The view south-east along Cromer High Street of the magnificent tower of the parish church of St Peter & St Paul has been published on more Cromer postcards than any other over the years. The tower with its distinctive crocketed pinnacles, is the tallest of any Norfolk church at 160 feet, and being open to the public, provides a 'white-knuckle' architectural experience.

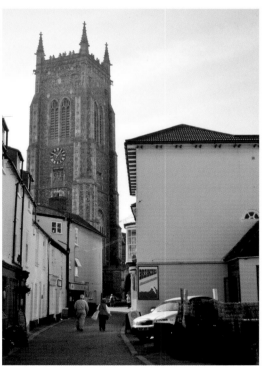

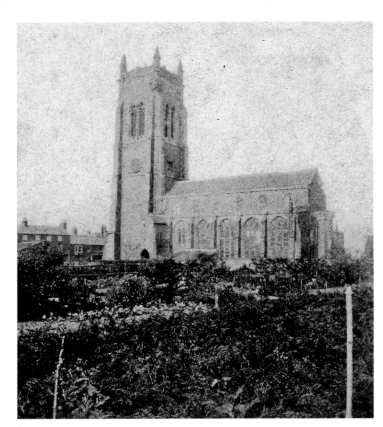

The Church Before Restoration

An early photograph of Cromer Church dated 4 May 1859. The building had suffered two centuries of neglect and is seen here without its chancel, which was blown up, with the permission of the Bishop of Norwich, in 1681. The buildings of Bond Street, whose backs loom large in the modern view from the same spot (now in Mount Street), do not quite block out the top of the tower.

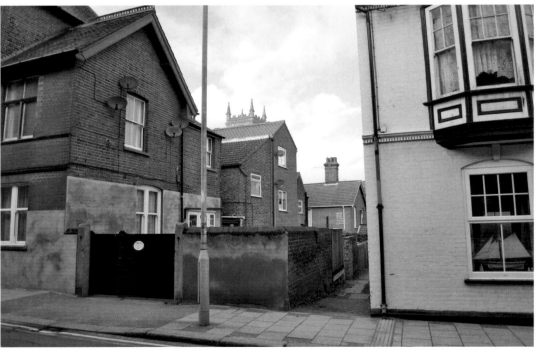

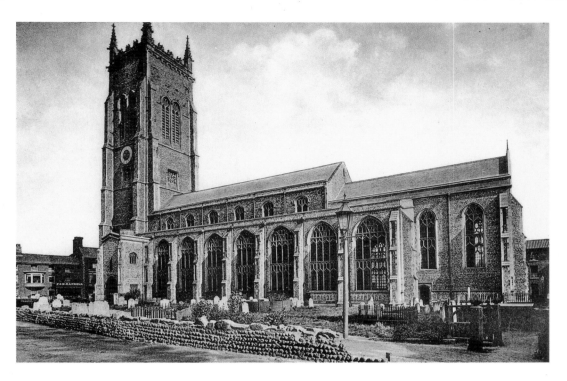

St Peter & St Paul Restored

Restoration of the church was completed by the end of the 1880s, by which time a new floor, a new roof and a rebuilding of the chancel on the footings of the original had been effected. The tower had also undergone restoration, its top being crenellated. The twentieth century saw the churchyard being reduced in size for road improvements; the low flint wall in the late nineteenth century view shows the former boundary line.

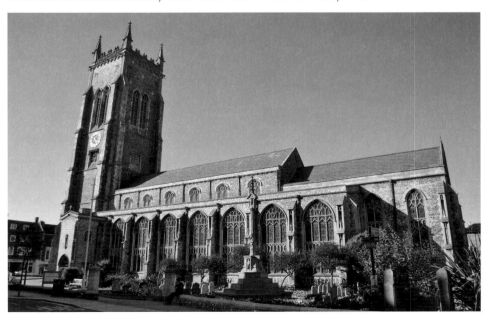

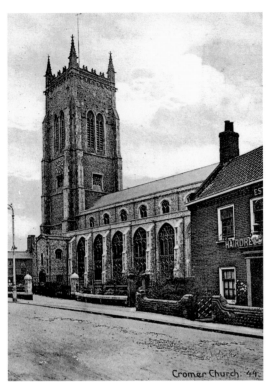

Cromer Church. 44.

Church Street Casualties

Both the buildings seen to the west of the
church (in the Church Square section of the
High Street) and to the east (the hairdresser's
and tobacconist's of T. Clarke) were
destroyed in the air raid of 22 July 1942, in
which twelve people died. Today, the Henry
Blogg memorial garden occupies the site of
Clarke's building. Most of the windows of
the church were blown out, but the main
structure of the building survived intact.

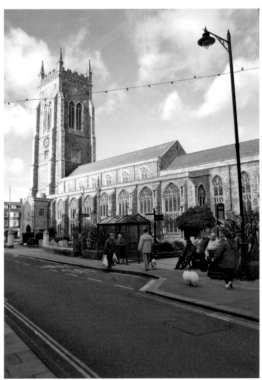

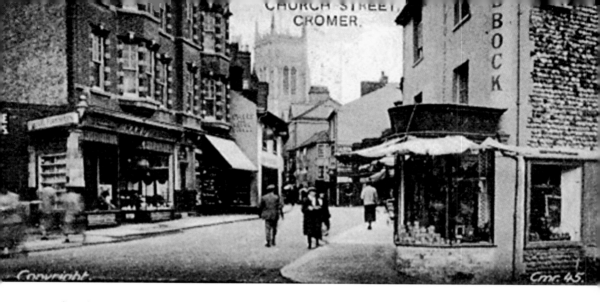

Church Street Looking West

The large building on the left, Hamilton House, was built in 1899. In the earlier view, taken in the mid-1920s, the furniture shop of A. Hardy occupies the nearest of the two shop units on the ground floor. The other shop (with the awning in the old photograph) was the newsagent and fancy goods shop of E. Battson before the First World War, who published many postcard views of Cromer.

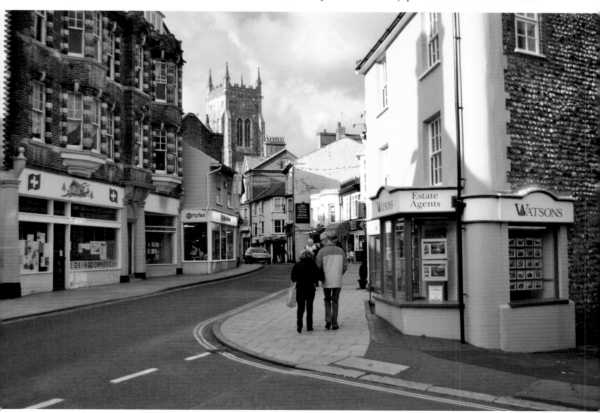

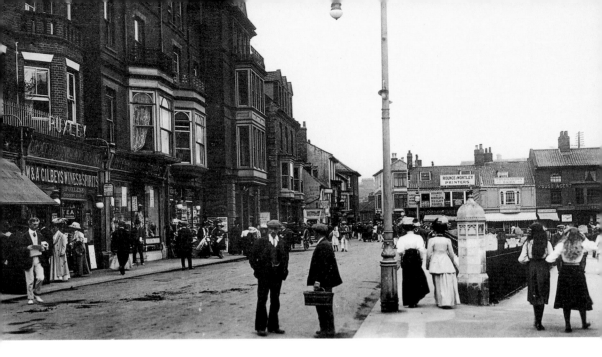

Church Street and Church Square

Bustling Church Street: in the middle distance the west end of the street can be seen. This was known as 'the Narrows' until in 1963 the buildings on the north side were replaced. The buildings facing the camera in the earlier view (at the Church Square end of the High Street; Rounce & Wortley and the Thurgarton Dairy) were destroyed in the air raid of 1942.

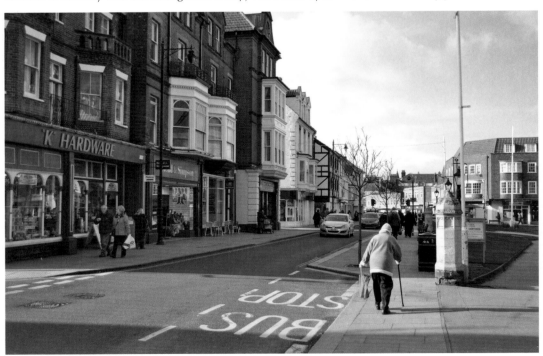

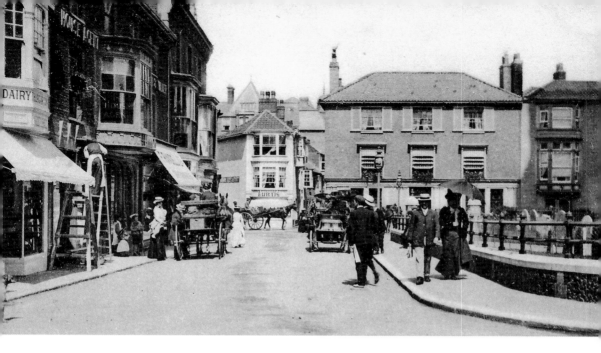

High Street

The south end of the High Street. To the left are the buildings of Church Square, while straight ahead can be seen Jetty Street heading to the cliff top between Curtis' shop and Barclays Bank. The bank was originally Gurneys, one of several local families who feature prominently in banking history. The building to the right of the bank in the earlier view is Tucker's Hotel. Originally, the Royal Oak and then the New Inn, it took the name Tucker from its owner George Cook Tucker, after whom the street in which it stood is named.

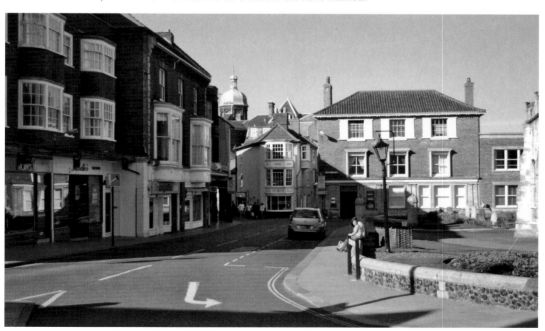

Jetty Street
The building to the right in the earlier view (without any of the bay windows which characterise the rest of the street) was the Tucker's Hotel Tap. In recent years horse-drawn transport has returned to Cromer's streets with this landau operated by Cromer Carriages.

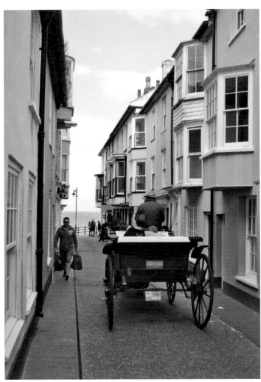

West Street

West Street, leading into Holt Road, is one of the roads which contained buildings dating from before Cromer developed as a holiday resort. The cottages in the earlier view have been replaced by late nineteenth-century shops, but the White Horse Inn with its shallow-pitched slate roof remains from earlier times. The building next to the White Horse housed the business of Jack Bryant in the 1950s who released records under the Cromer label.

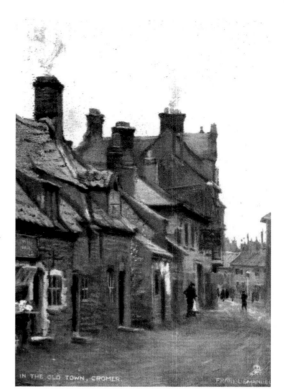

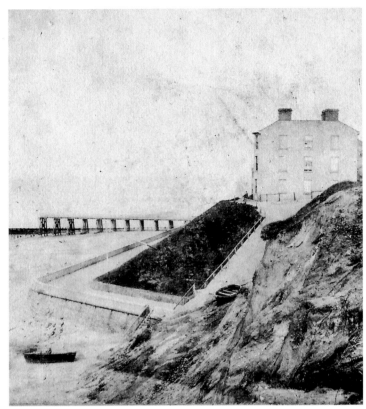

Melbourne Slope, 1850s
The slope down to the West Beach, from what was for many years the Melbourne Hotel, was also referred to as the West Gangway. The early photograph shows the western end of the sea defences erected after the Act of Parliament of 1845 passed to safeguard Cromer from further incursions by heavy seas. The jetty built at the same time had already lost its furthest three spans.

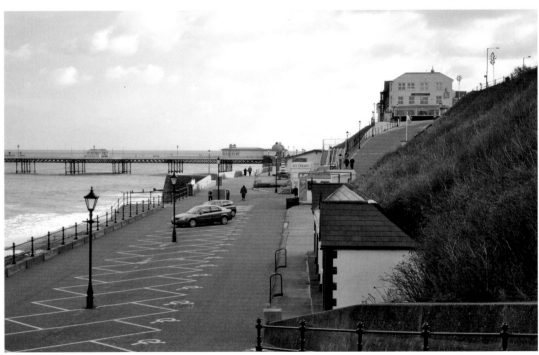

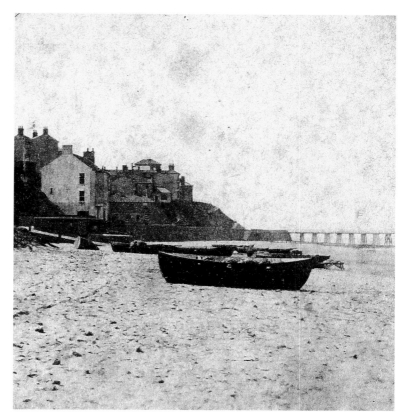

East Beach, 1850s
The original Bath House of 1814, without its 1871 extension, is seen to the right of Beach House, while Peele House in Tucker Street is visible from the beach in this early view which predates the construction of what are now the East Cliff flats. Further along the beach, the extended Hotel de Paris and the Tucker's Hotel Annexe (now the Old Lookout) are still to be built.

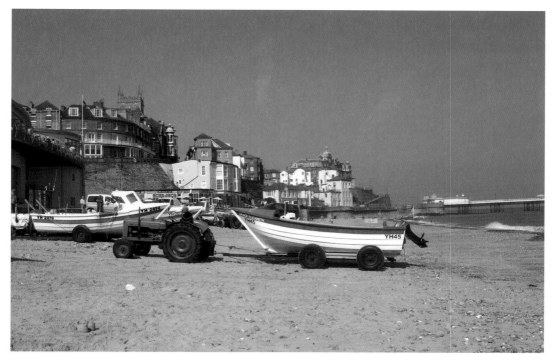

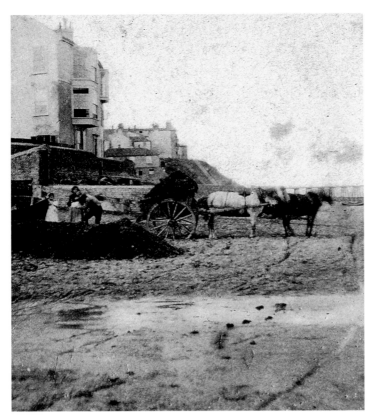

Beach House, 1859
Built in the early nineteenth century, Beach House (now divided into flats and called Marine View) has done well to survive the battering of heavy seas for nearly two centuries. Originally a flat-fronted, two-storey building, it had been built up another storey and received its bay windows by the time this photograph of seaweed being loaded was taken.

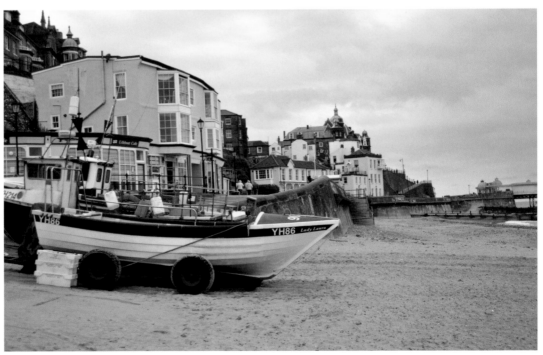

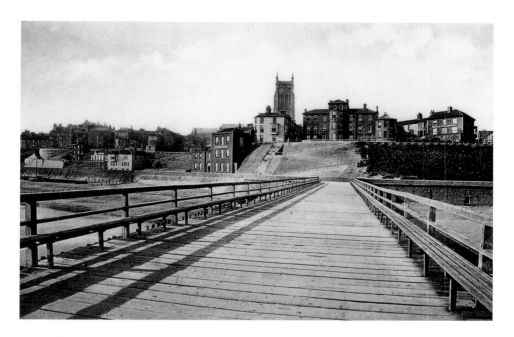

From the Jetty, c. 1890

The 1846 jetty was slightly to the east of the present pier. The old photograph shows the original two-storey houses of the Crescent on the extreme left, before their extensions upward and predates the building of the Hotel Metropole in 1893. At the head of the jetty, the old slope up to Jetty Cliff is seen; this was replaced with the present two slopes when the Hotel de Paris was rebuilt in 1894 to the design of George Skipper. The original Hotel de Paris is above the jetty; it was the summer residence of Lord Suffield until 1830. Albert House with its two-storey bay is to the right of the Hotel de Paris, while to the right of that is the Belle Vue Hotel, whose structure was incorporated within the rebuilt Hotel de Paris.

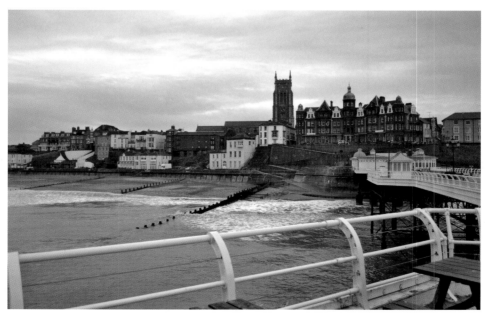

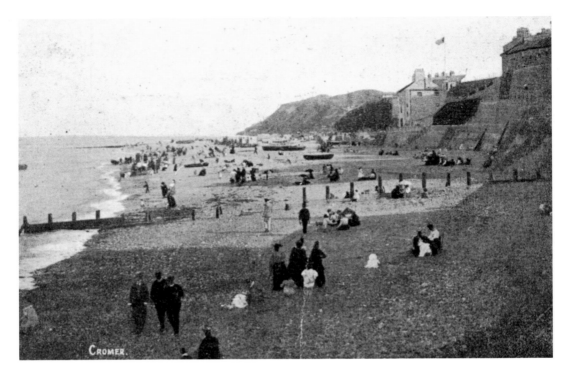

East Beach from the Jetty
A very early postcard from the 1890s showing a busy East Beach. The present promenade has yet to be constructed.

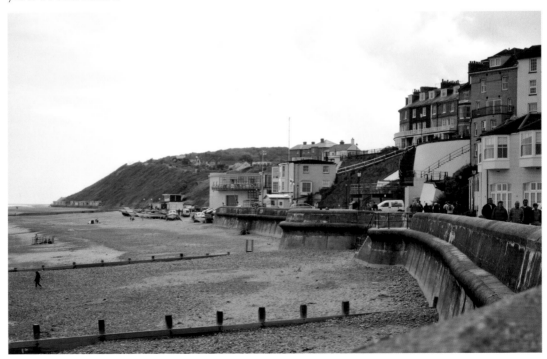

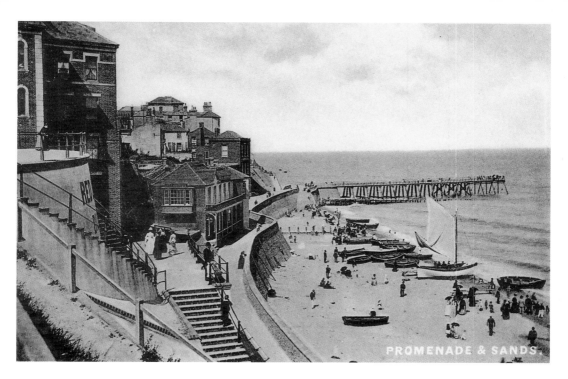

East Promenade, *c.* 1890
The narrowness of the 1840s promenade is evident in this view from the steps down from East Cliff to Beach House. The Bath Hotel's 1871 extension is prominent and an extension to the 1846 jetty making good the three spans lost earlier can be seen.

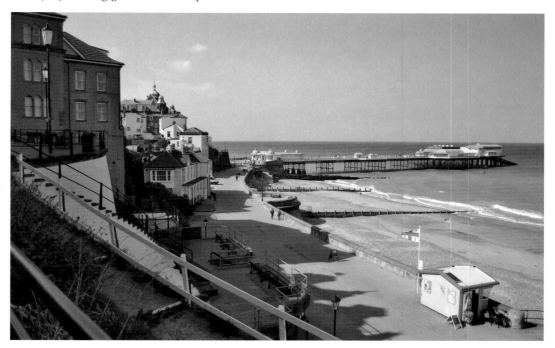

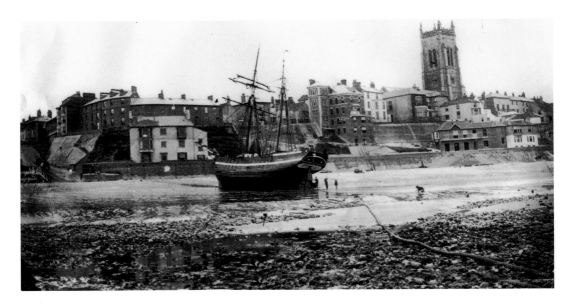

East Beach, *c.* 1871

Before the opening of the Great Eastern Railway line to Cromer in 1877, the town functioned as a port. There had been a small harbour at Cromer, built with great expense and effort only to be destroyed in a storm in 1611, but for centuries small coastal vessels would be beached at the bottom of The Gangway, unloaded at low tide and then refloated at the next high tide. Here the *Wensleydale*, which belonged to Jeremiah Cross of Brunswick House, is seen at low water. Coal was the main commodity brought into Cromer; corn was the main export. This view is noteworthy for showing the extension of the Bath House under way and the old Red Lion building before its reconstruction in 1887.

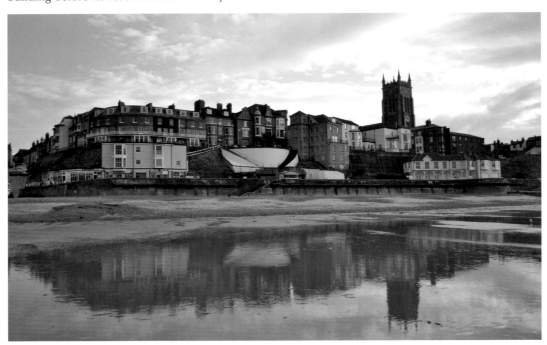

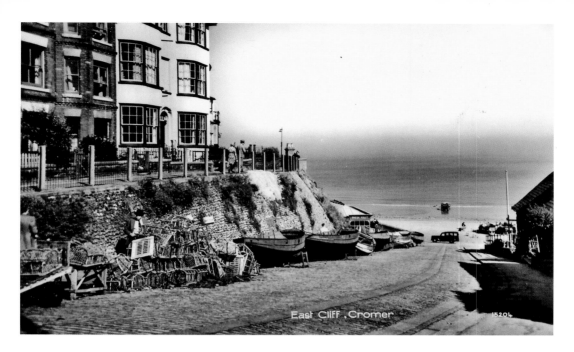

East Cliff, Cromer

The Gangway

Sometimes referred to as the slipway, The Gangway is crucial to Cromer's maritime activities. The bay windows of ship owner and coal merchant Jeremiah Cross's Brunswick House are seen to the left. Ironically, The Gangway only received its granite sett surface in 1887, just as the opening of the Eastern & Midlands Railway line to Cromer Beach Station killed off the last of Cromer's non-fishing sea traffic.

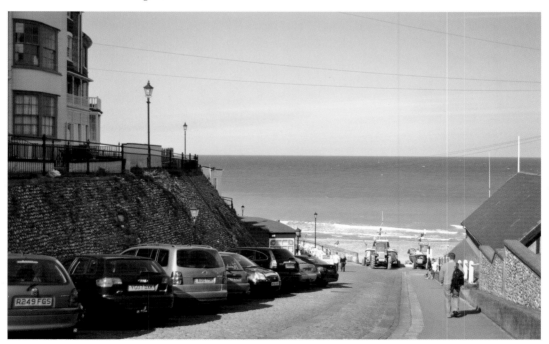

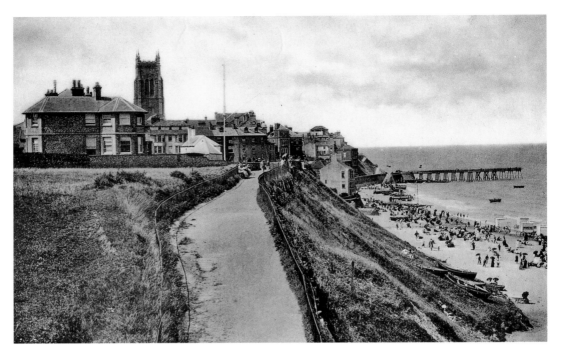

East Cliff, *c.* 1890
Heading east from The Gangway, this view shows the then coastguard station (painted white in the middle of the picture) and, nearest the camera, North Lodge. This building was home to members of the Hoare family in the nineteenth century, who donated it to the town and was later council offices. Today its grounds are North Lodge Park.

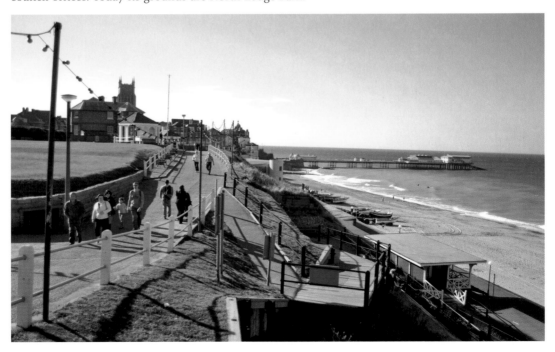

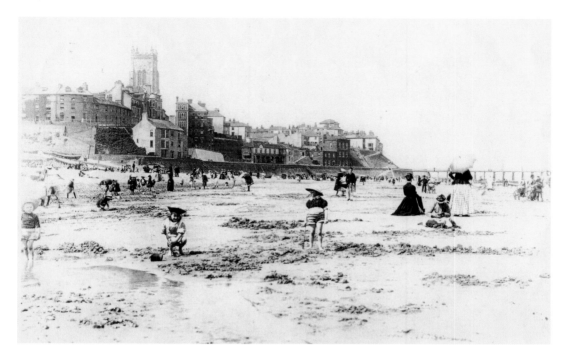

East Beach, *c.* 1890
The sands of East Beach at low tide are a perennial attraction to holidaymakers; the old photograph shows the then newly-rebuilt Red Lion Hotel with its distinctive turret above the roof of Beach House. The modern, early-morning view shows the Rocket House Café and Henry Blogg Museum, opened in 2006.

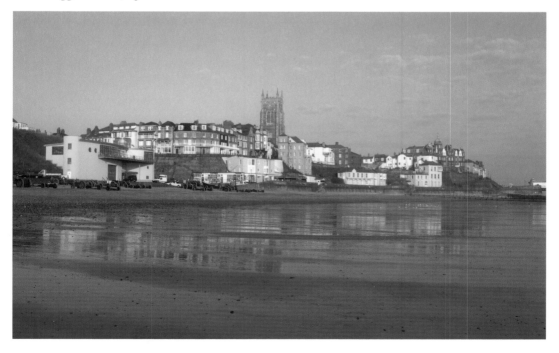

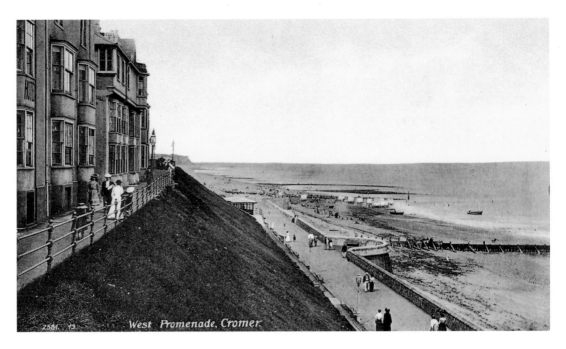

West Promenade, Cromer.

West Cliff and West Promenade

The Dolphin Hotel, nearest the camera with its flat bay windows, has been a feature of the West Cliff for around two centuries. Originally, the West Cliff Hotel, then the Regency and for a while in the 1980s Crabs, it is regularly illumiinated by spectacular sunsets.

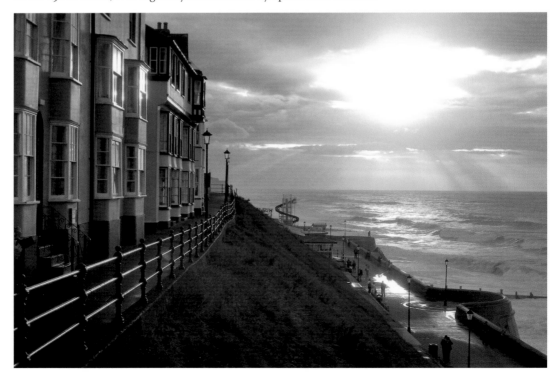

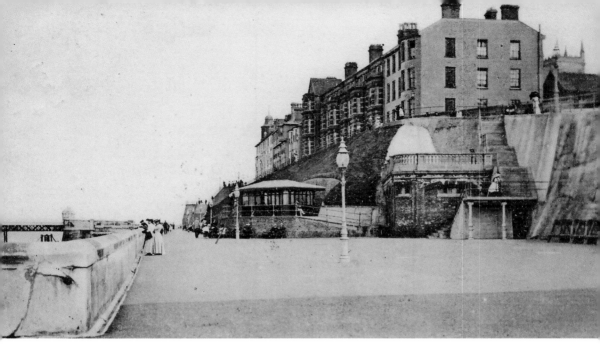

West Promenade and the Melbourne Hotel

Secure behind the massive sea defences of the 1900 promenade, the buildings of West Cliff offer commanding views of the pier and the sea. The Melbourne Hotel is today the Regency Fish & Chip Restaurant at ground floor level and Giovanni's Bar upstairs. Its basement is also host to Anastasia's nightclub.

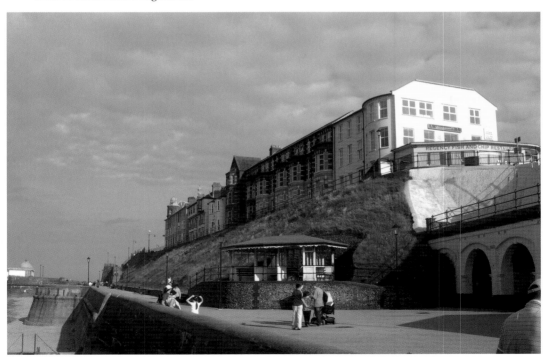

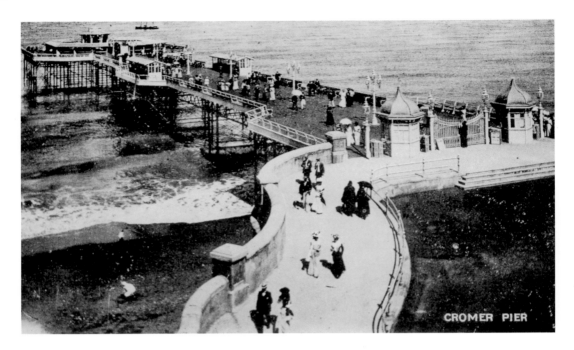

The Pier

The 70-yard jetty was demolished in 1897 and replaced by the 183-yard-long pier, which opened in June 1901. Plans had been drawn up for a pier in front of the Red Lion and the steps which descend from the hotel have every appearance of having been built with this in mind, but in the end the site just a few yards west of the old jetty, in front of the Hotel de Paris, won out. The pier was built with a bandstand at its seaward end; this can be seen in the early photograph.

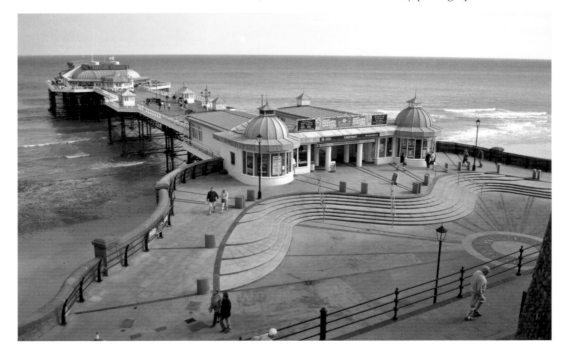

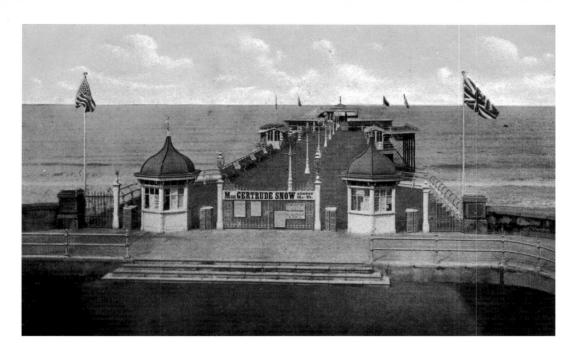

The Pier from Jetty Cliff

Musical performances were regularly held at the bandstand at the end of the pier, but the competition to be heard against the sound of the wind and the sea must have been hard. A covered-in pavilion was built in 1905 and today the Pavilion Theatre is of national renown as the last pier theatre offering traditional season-long variety entertainment.

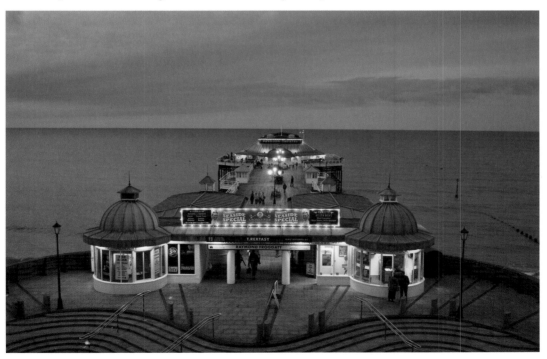

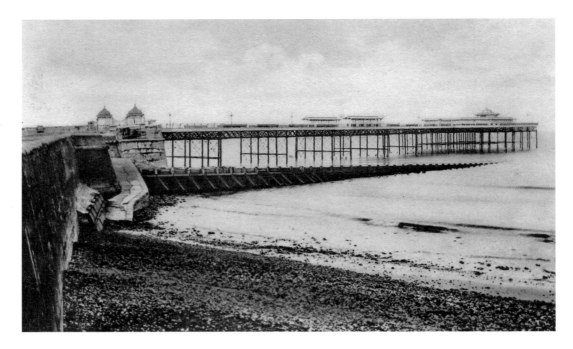

The Pier from the East Side

Cromer Pier has been breached twice since 1901; in 1940 a section was blown up to prevent easy access for potential German invaders and in November 1993, when the landward section was destroyed by a runaway oil rig offshore platform. The opportunity was taken to add new facilities to this end of the pier when it was rebuilt.

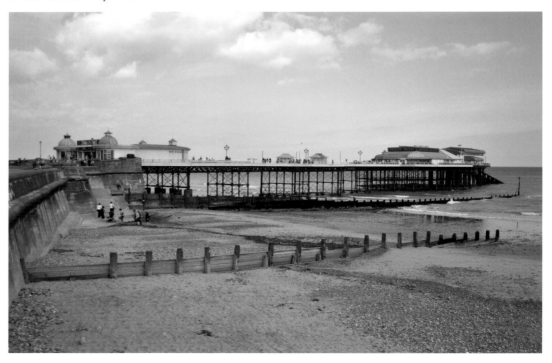

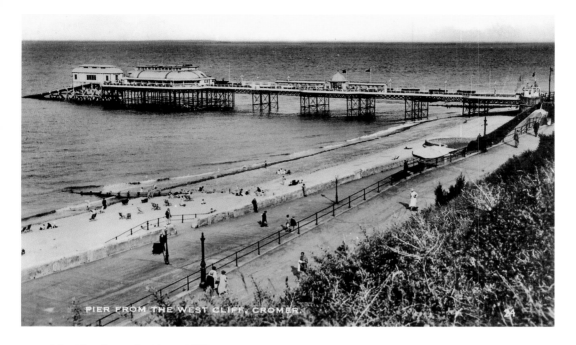

The Pier from the West Cliff
The earlier view shows the second Cromer lifeboat station which was added to the end of the pier, with a slipway enabling the launching of the new motor lifeboat straight into the sea whatever the tide. This lifeboat station was completed in 1923. It was replaced with a new, larger building in 1998, as seen in the contemporary view. The 1923 building lives on, in Southwold, Suffolk, where it is the Alfred Corry Museum building, having been cut in half and moved by sea.

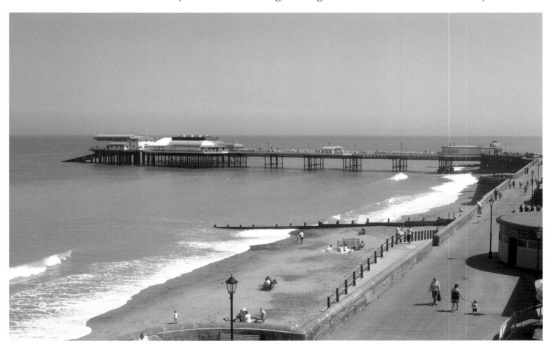

The Pier from the East Showing Pavilion

The earlier view shows the pavilion around the bandstand as first constructed. The theatre has undergone many improvements over the years; notably in 1954–55 when it required rebuilding after the storms of 1953 and in 2004 when its seating capacity was increased to 510 and the bar area rebuilt as Tides restaurant.

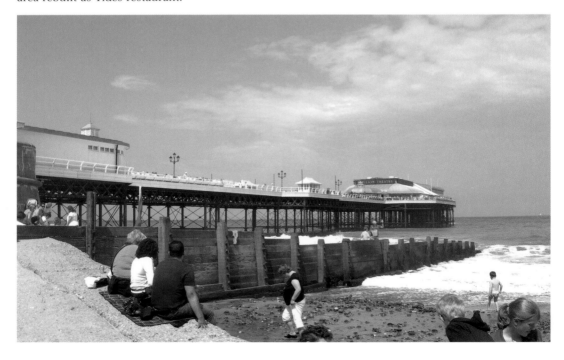

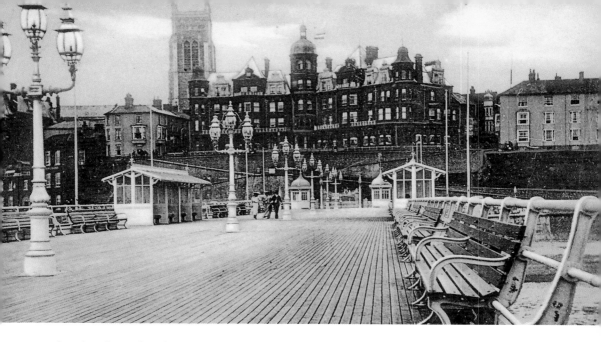

The View from the Pier

Looking back towards Jetty Cliff, the early view catches the pier at a quiet moment. In the 2010 photograph the new buildings created for the reopening of the pier in 1994 can be seen at the entrance.

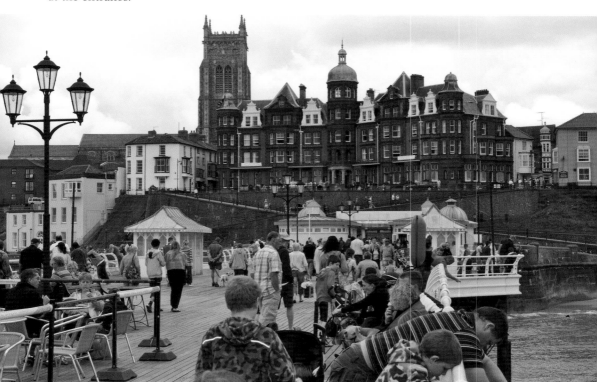

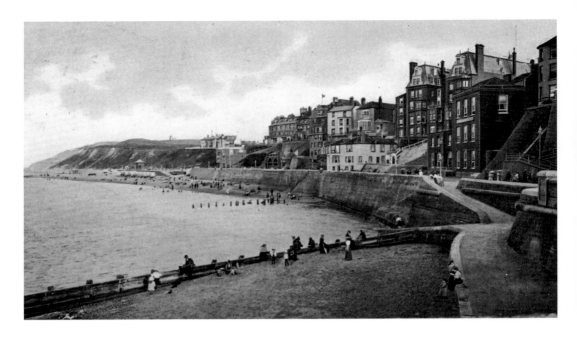

East Beach from the Pier

The earlier view at high tide shows the twin wings of the Hotel Metropole brooding over the East Beach. Beneath them, also in red brick, can be seen the annex to Tucker's Hotel where the Empress Elizabeth of Austria stayed for two months in 1887. She had a great (and justified as it turned out) fear of assassination and insisted on drinking only milk from a cow that had been milked on the promenade while she looked on. Henceforth, Tucker's Hotel styled itself Royal Tucker's.

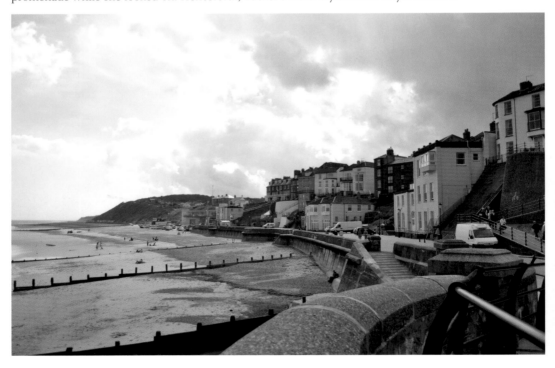

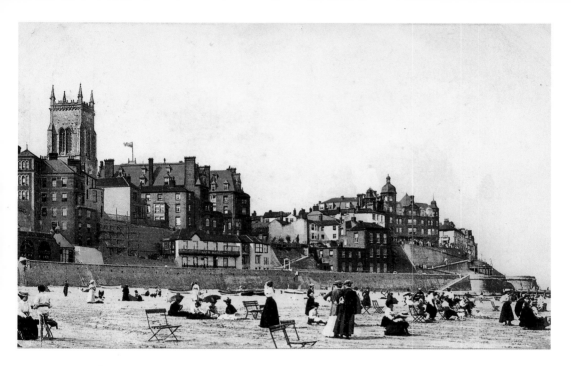

East Beach, *c.* 1905
The first decade of the twentieth century was the heyday for Cromer's great hotels. The Hotel Metropole, seen in the centre of this view, was accessed directly from the promenade, to the right of the Bath Hotel. The Hotel Metropole was used to accommodate troops during the Second World War and never reopened as a hotel afterwards. It was demolished in the 1970s and flats have been built on the Metropole's foundations.

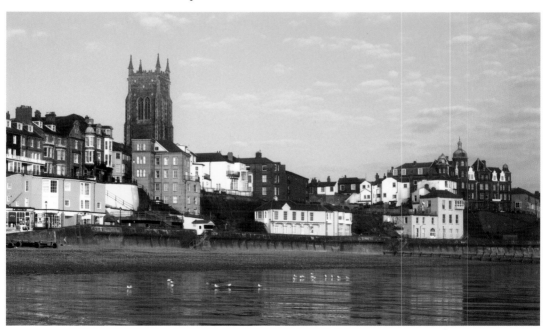

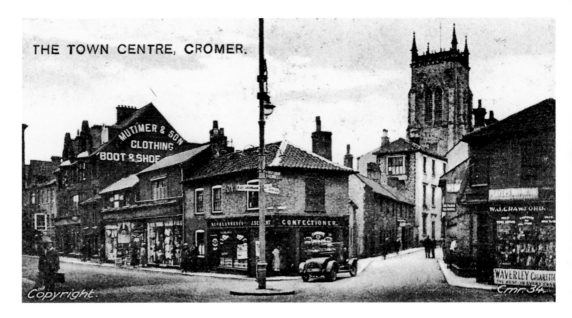

THE TOWN CENTRE, CROMER.

Town Centre Mid-1920s

The junction between Garden Street (to the left), Church Street (straight ahead), Chapel Street (to the right), Hamilton Road and West Street (both behind the camera) is usually referred to as Crossways. Sergeant's Café, later the Workers' Café, behind the car in the earlier view marked the start of the part of Church Street known as 'the Narrows' and was demolished in 1963. Mutimer's buildings in Garden Street (both the tall building with the gable inscription and the two lower buildings nearer the camera) suffered extensive bomb damage in 1942, but were repaired.

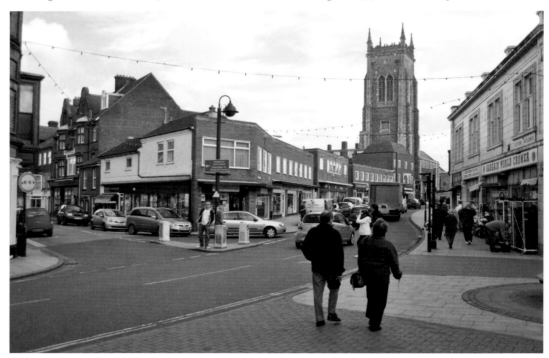

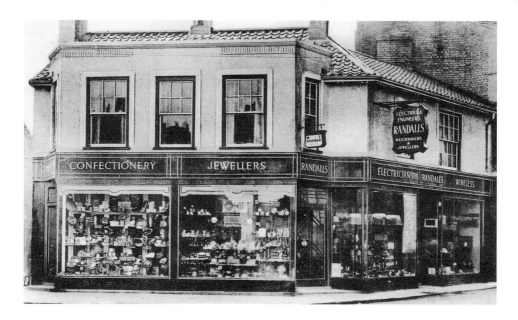

Crossways

The building between Chapel and West Streets at Crossways has undergone many changes over the years. In the nineteenth century, it was a private house called Fountain House. In those days the town pump was here (before being called Chapel Street, the road to the left of the building was Pump Street). Later the house became offices for Cromer Urban District Council, before becoming Randalls. Randalls moved to a shop in the former Imperial Hotel at the east end of Church Street in the 1960s (next door to where the business of another branch of the family have moved in recent years) before ceasing to trade. The Crossways building is now the Cromer branch of Lloyds TSB.

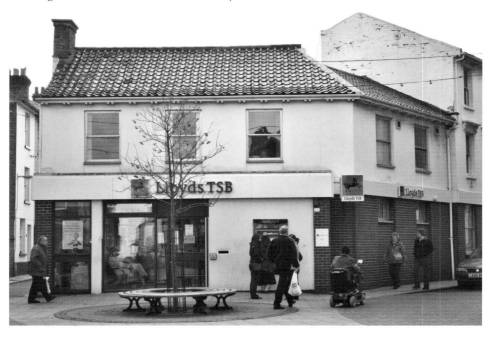

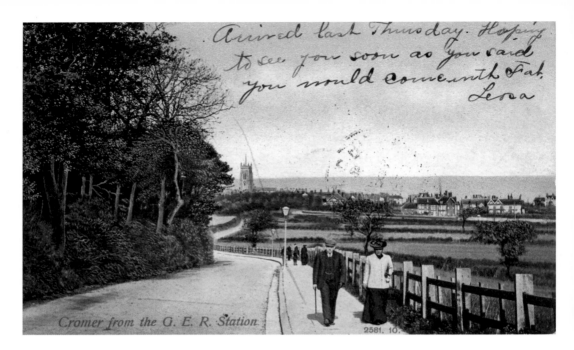

Arrived last Thursday. Hoping to see you soon as you said you would come with Fat. Leona

Cromer from the G. E. R. Station

2581. 10.

The Railway Age

Cromer's steady growth as a seaside resort accelerated massively with the opening of the East Norfolk branch of the Great Eastern Railway in 1877. The Great Eastern station was a mile to the south of the town on the Norwich Road and once the station of the rival Eastern & Midlands Railway opened ten years later would be known as 'Cromer High' and was officially named as such with the advent of British Railways in 1948. The coming of the railway led inevitably to the town stretching out to meet Cromer High station, but at the time of the earlier view there were still green fields between station and town.

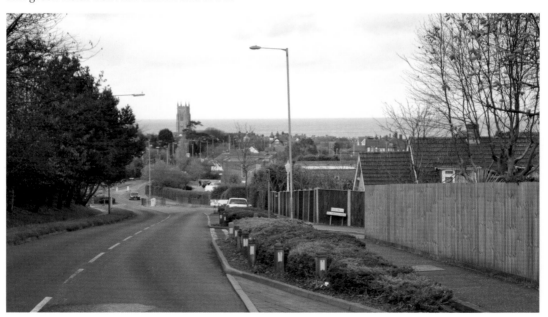

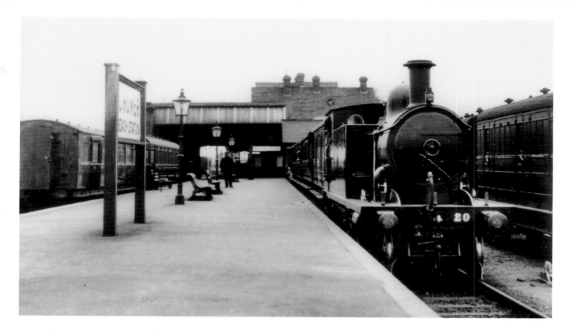

Cromer Beach Station

The Eastern & Midlands Railway (later Midland & Great Northern Joint Railway) station at Cromer Beach was much more convenient than Cromer High and the latter closed to passengers in 1954 and completely six years later. Now known simply as Cromer Station, Beach Station continues to be well served by trains from Norwich. In the earlier view a Class A 4-4-2T designed and built by the Midland & Great Northern Joint Railway at its Melton Constable Works stands at the station with a short train before the London & North Eastern Railway took over in 1936.

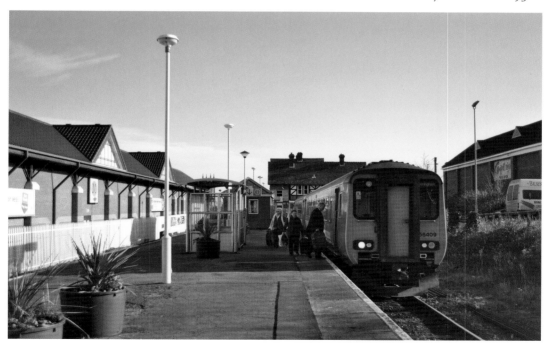

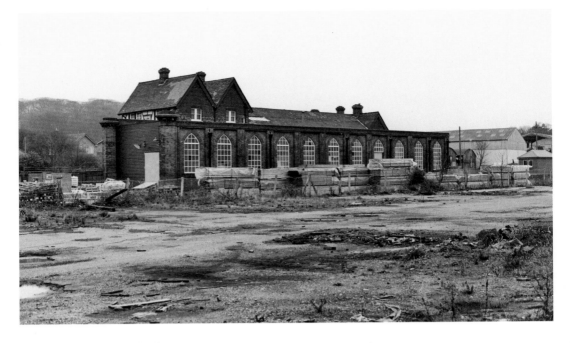

Cromer Beach Train Shed

An impressive station building was erected by the Eastern & Midlands Railway with a train shed running along its length providing cover for two carriage lengths. The longer of the two platforms was cut back in the 1960s and the train shed and station buildings were occupied by the builders' merchant Travis & Arnold. The station buildings remain and now form the pub Buddies, but the train shed has not survived.

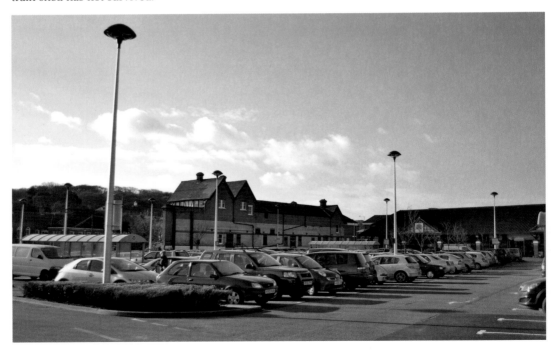

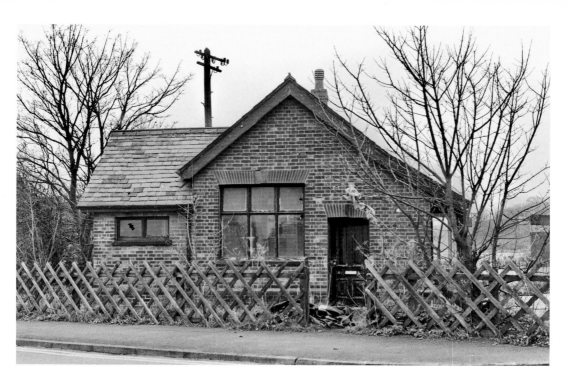

Cromer Beach Yard

Cromer Beach Station had extensive sidings, a goods shed and a locomotive shed. While the latter closed in 1959, it remained, along with other buildings, until 1991 when the site was cleared to allow the construction of the Safeway supermarket (now Morrisons). Here, the office to the right of the entrance to the goods yard is seen in 1990 with typical Midland & Great Northern Joint Railway fencing in evidence.

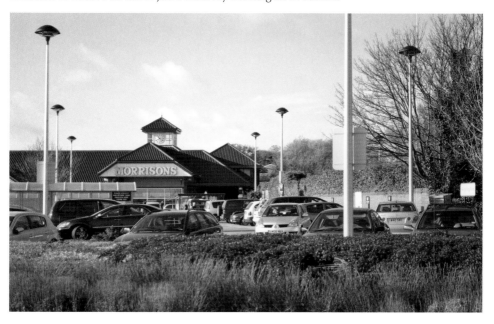

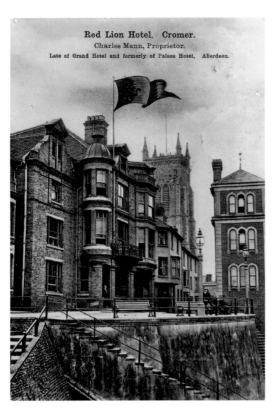

Red Lion Hotel, Cromer.
Charles Mann, Proprietor.
Late of Grand Hotel and formerly of Palace Hotel, Aberdeen.

Red Lion Hotel

The opening of the railway sparked a boom in hotel construction in Cromer. The first major work was not the construction of a new hotel from scratch, but the rebuilding of one of the town's oldest inns, the Red Lion, which was completely reconstructed in 1887. The bars retained their 1887 layout and fittings for almost 100 years before a major refit in the 1980s and the Red Lion remains at the centre of Cromer life today.

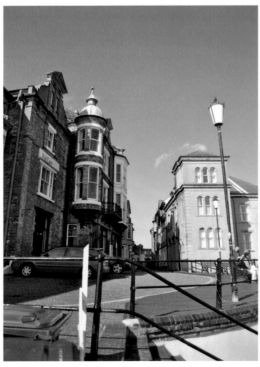

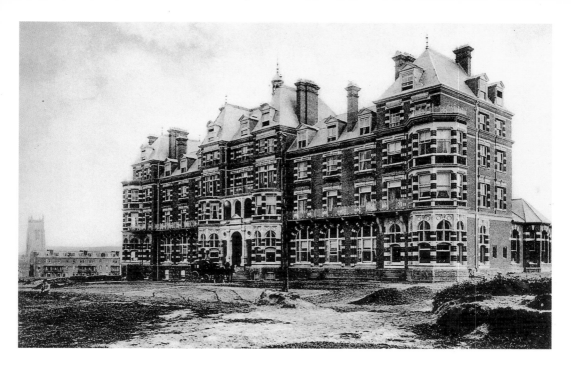

Grand Hotel

The first major new hotel constructed in the 1890s was the Grand, which went up along the Runton Road in 1891. In the 1960s it was renamed the Albany Hotel, but did not survive long, being badly damaged by fire in 1969 and replaced by Albany Court flats.

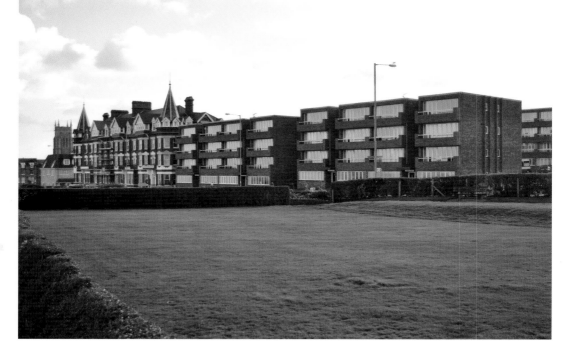

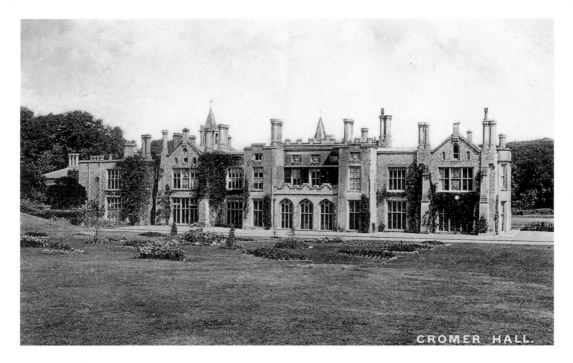

Cromer Hall

The Gothic mansion of Cromer Hall was built by George Wyndham between 1827 and 1829 and was sold to Benjamin Bond-Cabbell in 1852, since when it has remained in the hands of the Cabbell and Manners-Cabbell family. It was over dinner at Cromer Hall in 1901 that Sir Arthur Conan Doyle had the inspiration to write the novel *The Hound of the Baskervilles*. His host Benjamin Bond-Cabbell told him about his ancestor Richard Cabbell, who had been killed by a devilish dog on Dartmoor.

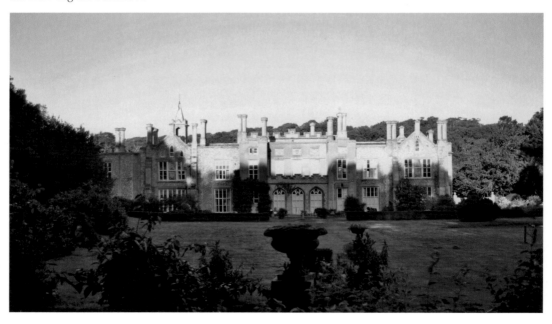

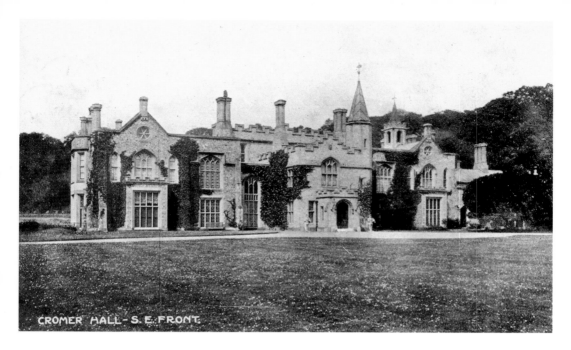

Cromer Hall East Front

The early view shows the ivy growing across the eastern front of Cromer Hall which is mentioned by Conan Doyle in his description of Baskerville Hall. It was the sale of a large part of the Cromer Hall estate in 1891 which released land to the west of the existing town of Cromer for development.

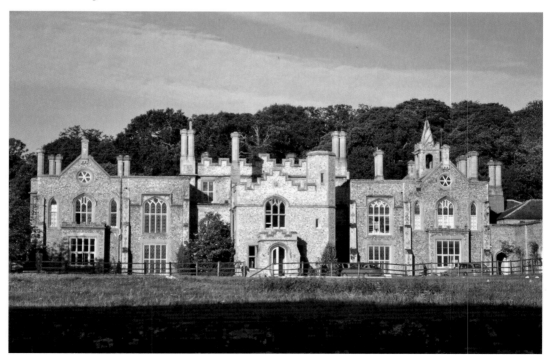

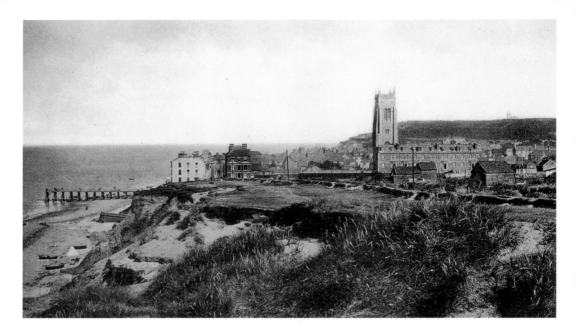

West Cliff, *c.* 1890
The view looking eastwards at the cliff top close to Runton Road before the developments that followed the sale of part of the Cromer Hall estate. The modestly-sized house with two bay windows in the centre of the picture is of note. This was the then recently built Marlborough House, which would be extended in stages southwards along Prince of Wales Road to form the Marlborough House Hotel (see page 52).

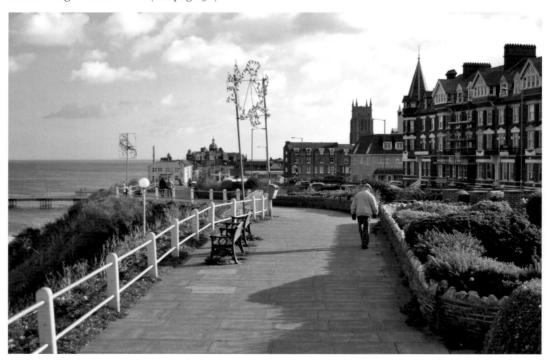

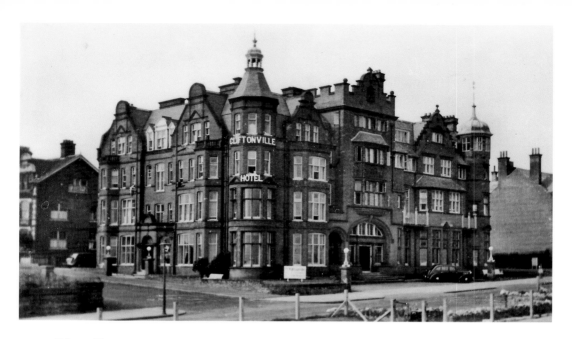

Cliftonville Hotel

The Cliftonville Hotel was built in 1894. It saw military use during the Second World War and is one of the three large late Victorian hotels in Cromer still thriving. Its restaurant is called Bolton's Bistro, after Tom Bolton, who owned the Cliftonville and the Red Lion hotels in the 1960s and 1970s.

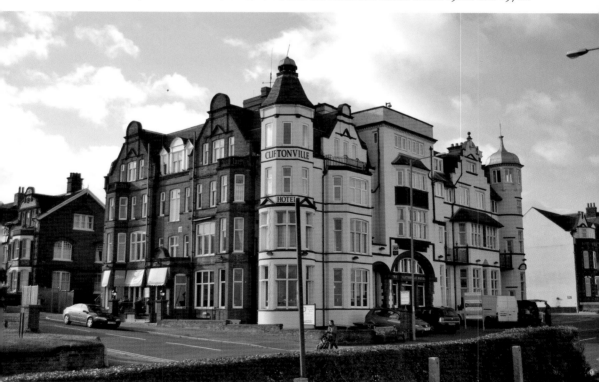

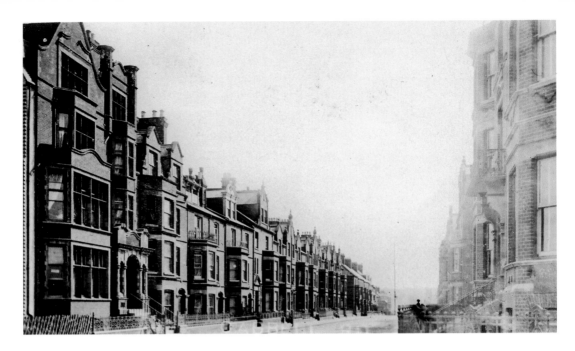

Cabbell Road

One of the roads laid out at the end of the nineteenth century after the sale of the Cromer Hall land, Cabbell Road runs south from Runton Road to connect with West Street. Many of the grand Victorian terraced buildings are today subdivided into flats.

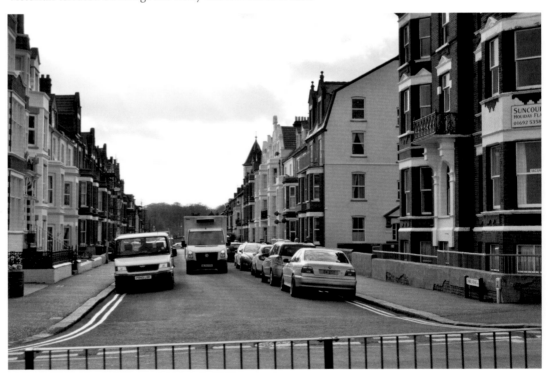

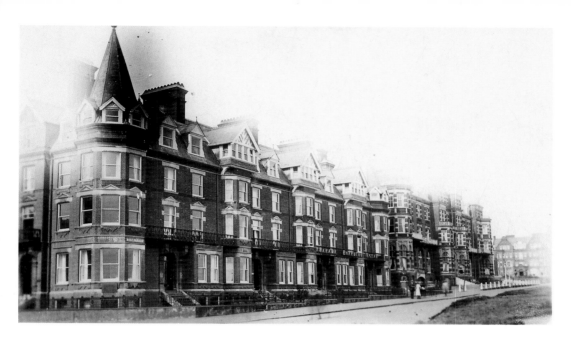

West Parade

West Parade was constructed along Runton Road between Cabbell Road and the Grand Hotel. A view of the rear of this range of buildings accompanies the first glimpse of the sea that the train traveller gets across the fields as they approach Cromer.

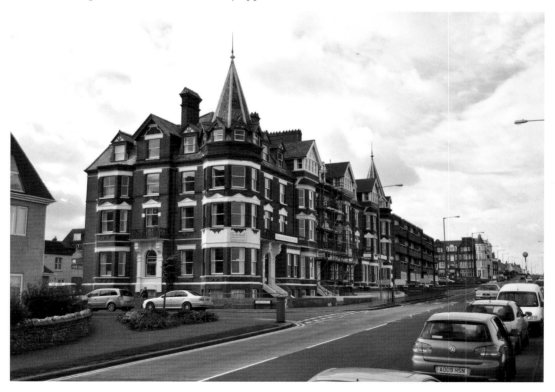

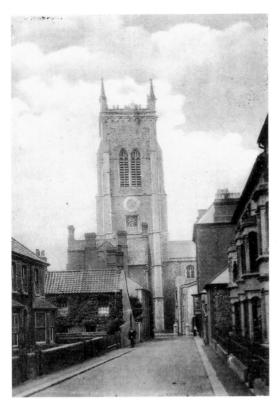

Hans Place

Originally known as the Loke, Hans Place was renamed after Hans Hamilton, brother-in-law of Benjamin Bond-Cabbell. At the far end of the road in the earlier view, Britannia House on Church Street can be seen, partly obscuring the church tower. This building is today Superdrug. The cottages running west from Hans Place seen in the earlier view were replaced by 1914 when the Cromer Theatre of Varieties was opened behind Britannia House. After a period as the Central Cinema, it was renamed the Regal in 1930. Today owned by the Merlin Cinema group, the now-multi-screen Regal Multiplex thrives in a manner similar to the Pavilion Theatre on the pier.

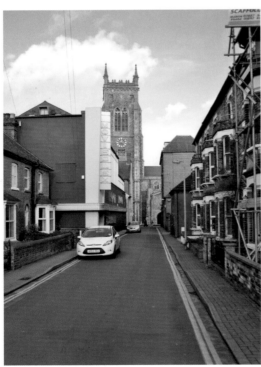

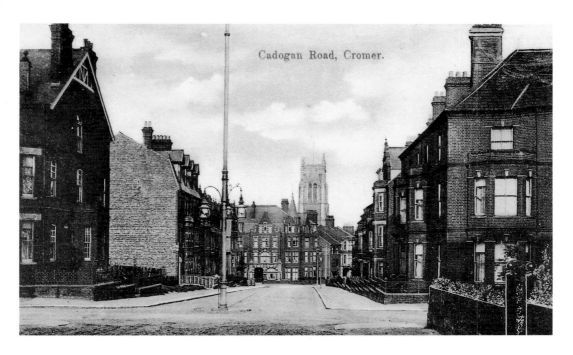

Cadogan Road, Cromer.

Cadogan Road

Cadogan Road looking east towards the town centre, showing in the foreground the crossroads with Cabbell Road, and the Mayfair Hotel (with truncated chimneys) on the right. After the closure of the bus station at the bottom of the road in April 2007, the bus stop in Cadogan Road was the main departure and terminating point for Cromer bus services.

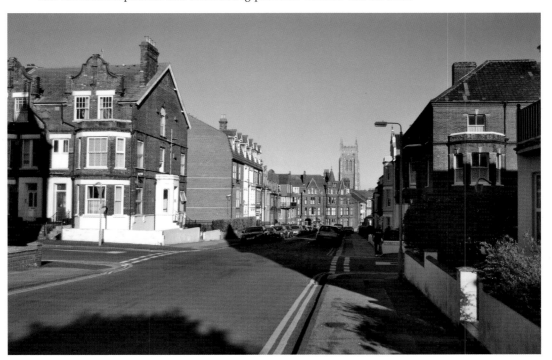

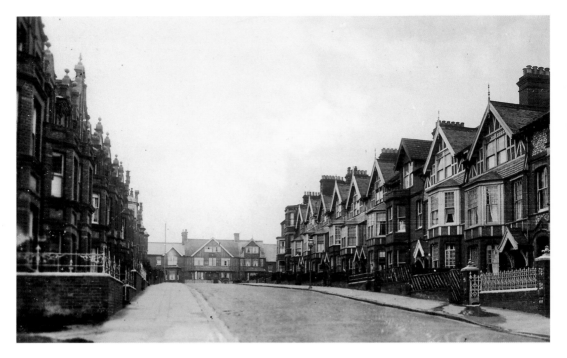

Alfred Road

Alfred Road looking towards Bernard Road. This street suffered badly when it was bombed on Good Friday 1941. Three WAAFs billeted at the Lyndhurst Hotel in Alfred Road were killed along with a civilian who died from shock shortly afterwards. Five houses were destroyed; Alfred Court flats (left) now occupy their site.

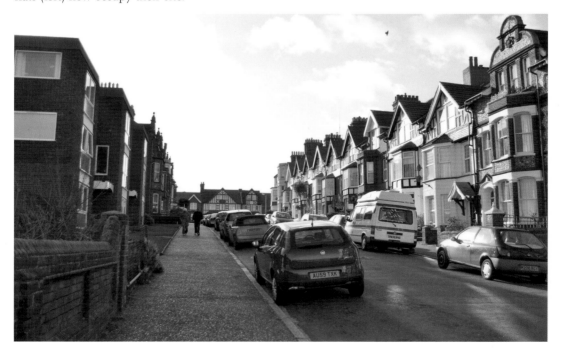

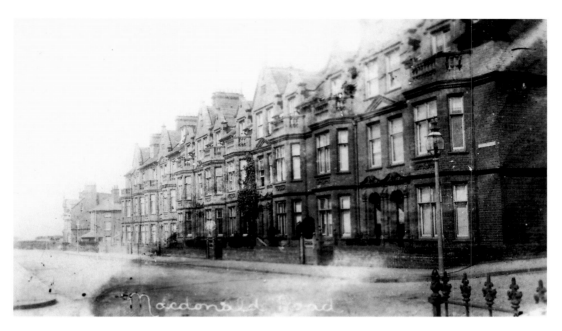

Macdonald Road

Macdonald Road marks the western extent of the roads of imposing buildings erected at the end of the nineteenth century, many of which are guest houses, such as the Glendale, nearest the camera.

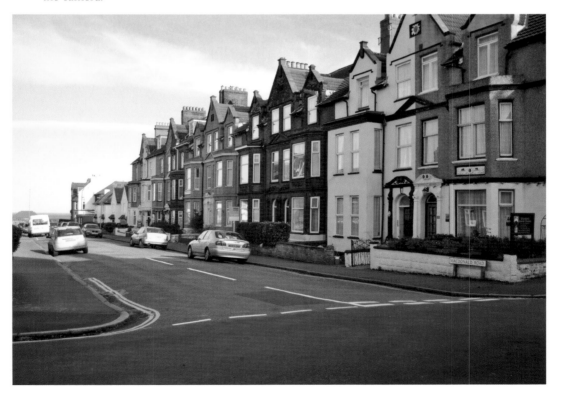

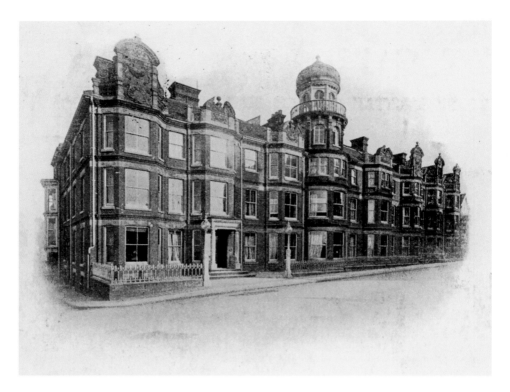

Marlborough House Hotel

By the early twentieth century, the Marlborough House Hotel had grown up from modest beginnings (see page 44) to one of Cromer's largest hotels. Troops were billeted here during the Second World War and afterwards the Marlborough did not reopen. Demolished in 1957, its ballroom remained for some years and was used as the showroom for Jessop Bros. garage. Today, the site is occupied by Morrison's filling station.

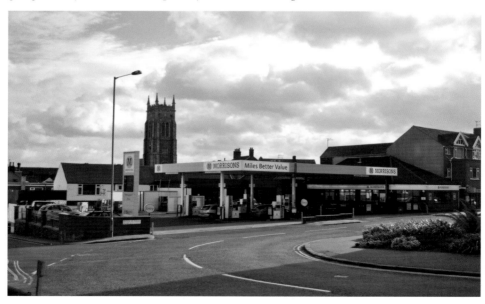

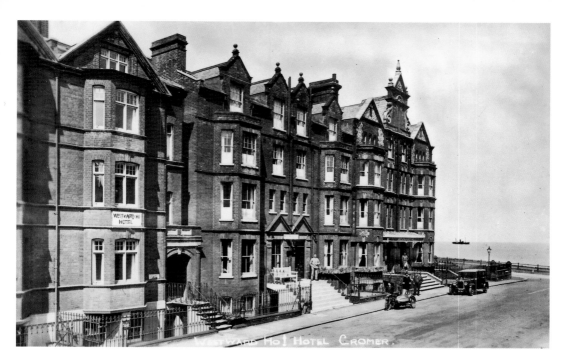

Westward Ho! Hotel

In common with the Marlborough House Hotel the other side of Prince of Wales Road, the Westward Ho! Hotel has long ceased to be open to paying guests. However, the building still survives, converted to flats, as Clevedon House.

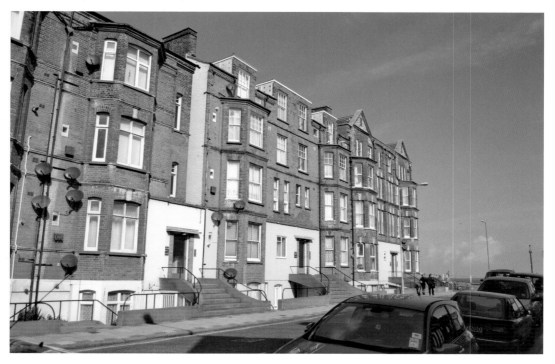

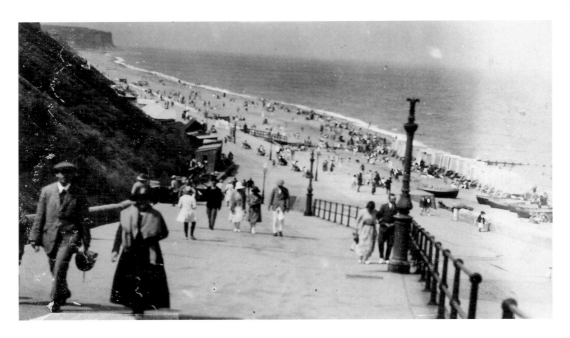

Melbourne Slope Looking West
Looking down the Melbourne Slope, formerly the West Gangway, on west beach. This provides a stiff challenge to the Cromer Road Train in summer months.

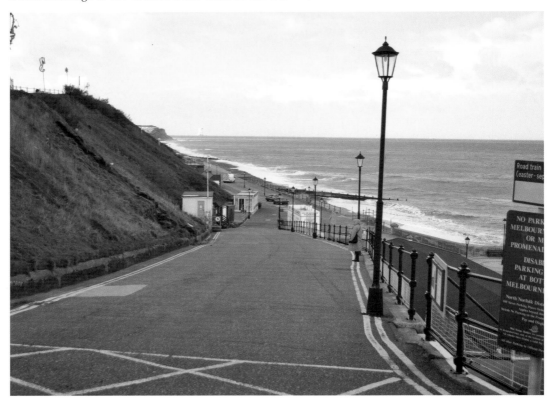

54

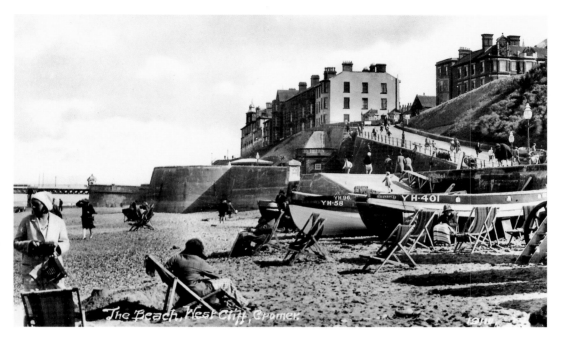

The Beach, West Cliff

Today Cromer's fishing boats are all concentrated on the East Beach, but in earlier days, some worked from the west beach. The Marlbourgh House Hotel peeps over the cliff top in the old photograph.

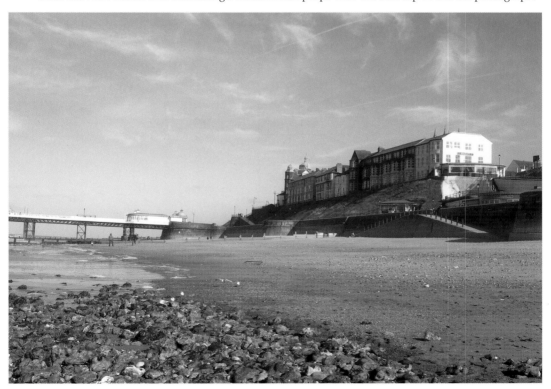

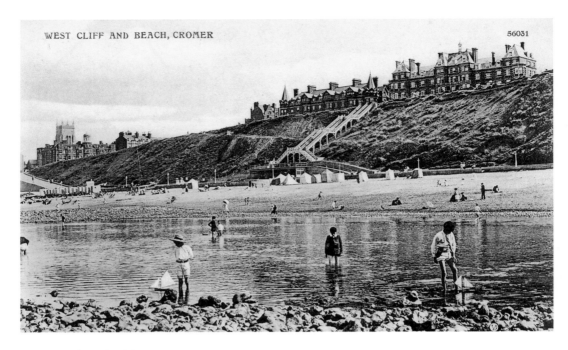

56031

West Beach and White Steps

The early view shows the White Steps down to the west beach, which were built at the same time as the Grand Hotel. Removed during the Second World War as a precaution against invasion, they were replaced by Anglian Water in the 1990s at the same time as a new sewer outfall was constructed.

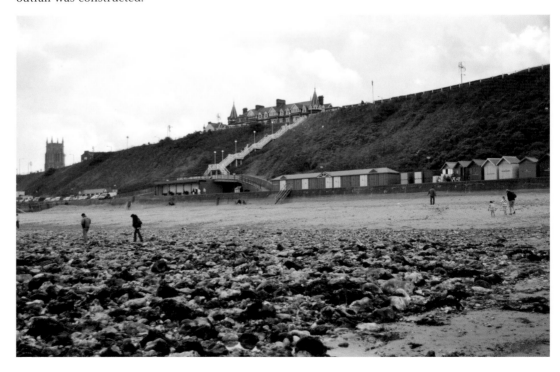

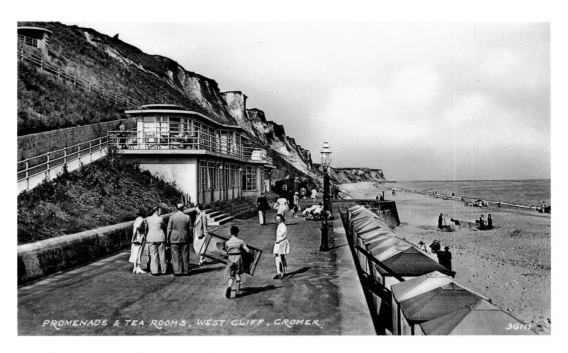

Promenade and Tearooms, West Beach

The tearooms at the western end of the promenade. Beyond here towards the East Runton Gap the cliffs are undefended against the sea. The beach huts on the beach have now migrated to permanent structures on the promenade.

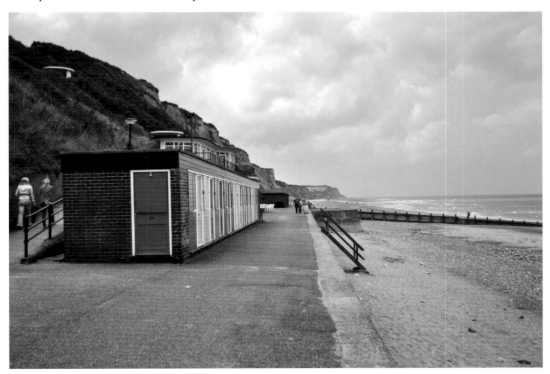

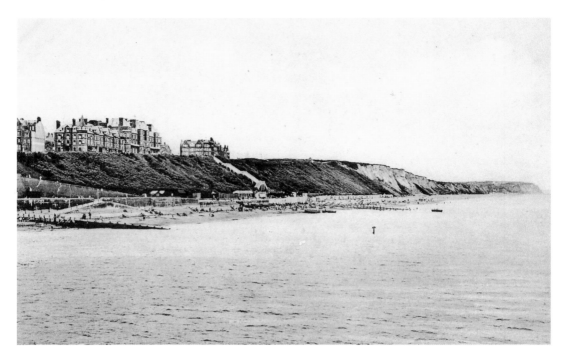

West Beach from the Pier
In the eighty years that separate these two views, the west beach has lost its bathing machines but gained a children's fun fair which operates throughout the summer season.

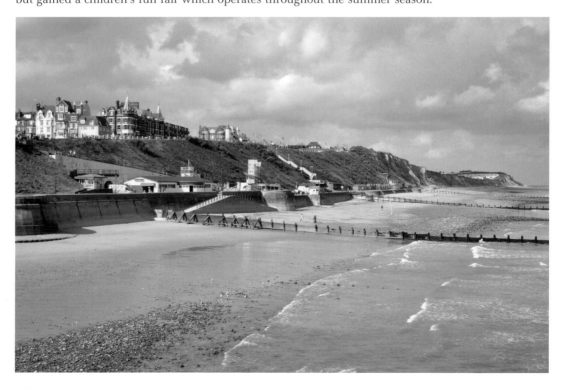

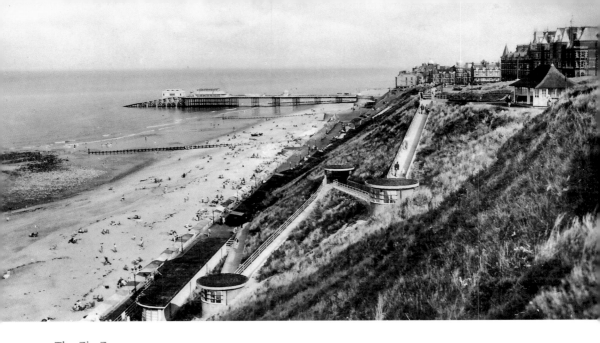

The Zig Zag

Direct access to the western end of the promenade from the cliff top was for many years provided only by the zig zag path with its distinctive round shelters at the end of each leg. A contemporary copy of the earlier view is no longer possible owing to the closure of part of the cliff top path due to subsidence.

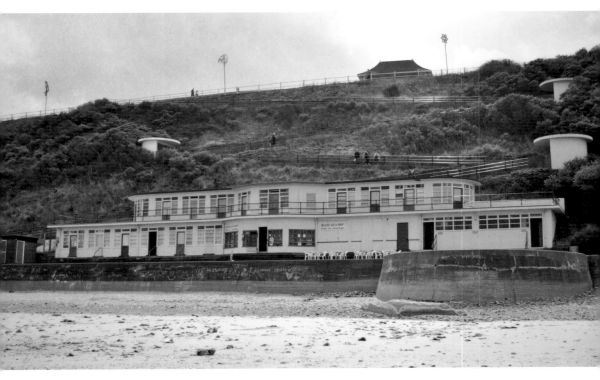

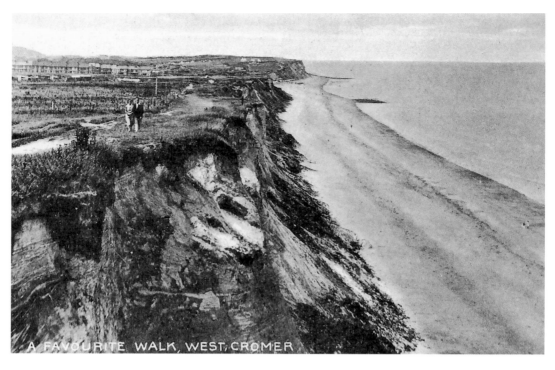

West Towards Wyndham Park

The terrace of houses distant in this view, Wyndham Park, marks the western boundary of Cromer. Caravan parks have increased greatly in popularity in the intervening years.

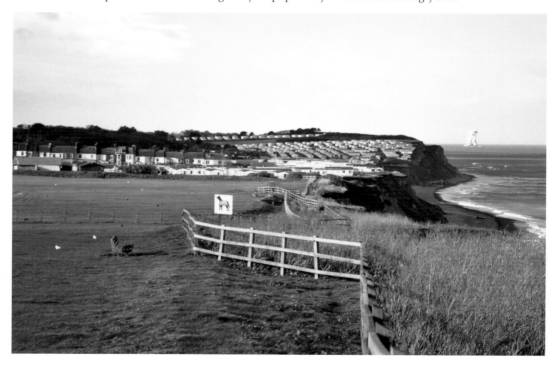

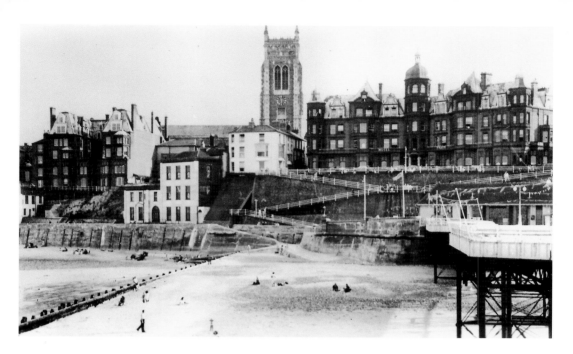

Church and Hotels

Although prominent in this post-war view, the Hotel Metropole had not reopened after the war and would remain as a slightly sinister empty building until demolition in the 1970s. In contrast, the Hotel de Paris prospered. It was updated in the 1960s with a new cocktail bar, without changing the essentials of its sumptuous interior, and remains open to this day.

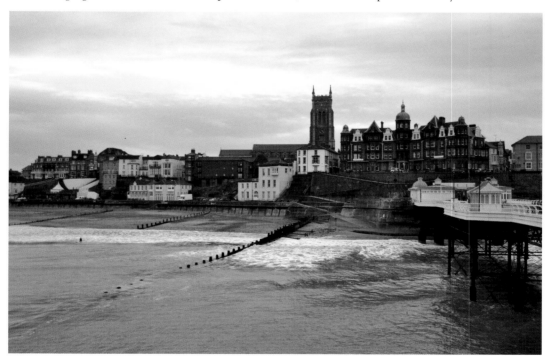

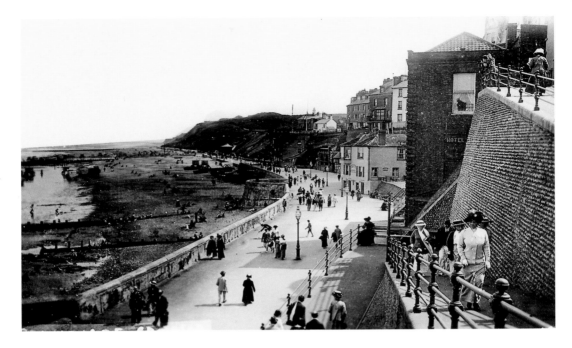

East Promenade from Jetty Cliff

The view east from the 1894 slopes below Jetty Cliff has changed little since the beginning of the twentieth century. The annex of the Royal Tucker's Hotel, often called Lower Tucker's, was in the 1960s the Punch & Judy Café. At the same time, its top floor was the coastguard station, the addition of the bay window affording a clear view of both the East and West beaches. Now divided into flats, the building is called the Old Look Out.

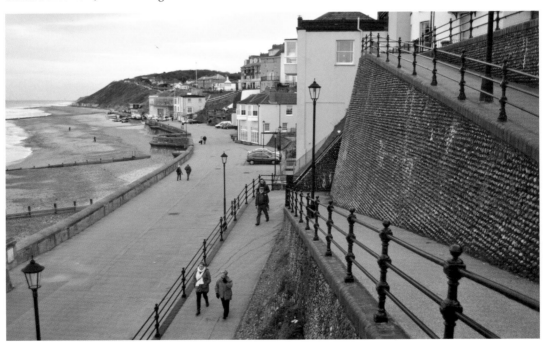

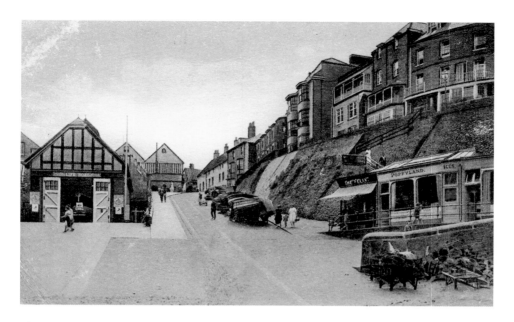

The Gangway and Lifeboat Station

The lifeboat station at the bottom of The Gangway was completed in 1868, replacing one further up The Gangway, which was demolished in 1882. The costs of construction and a new lifeboat were donated by Benjamin Bond-Cabbell. In 1923 the construction of the lifeboat station on the pier led to The Gangway Station being designated Cromer's second station and from 1970 it fell out of use. It then became a lifeboat museum, with the inshore lifeboat being housed variously in an 'igloo' on the west promenade and in a container on the East Beach. Since the opening of the Henry Blogg Museum just yards away in 2006, it has reverted to being an operational lifeboat station, housing Cromer's inshore lifeboat.

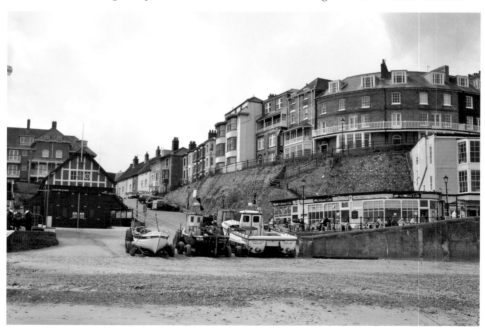

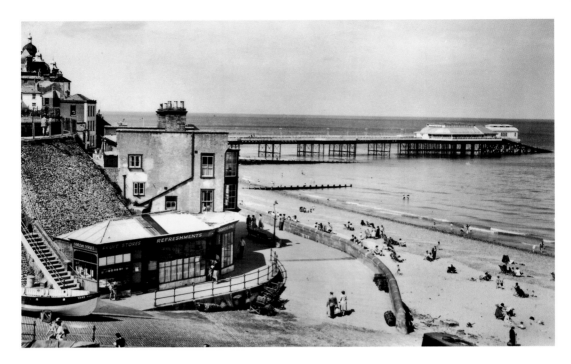

Gangway Bottom and East Beach
A small section of the original promenade survives outside the Lifeboat Café. Used in the season for the café's outside diners, it contrasts with the breadth of the promenade created at the turn of the twentieth century, which falls to meet the base of The Gangway. The modern view shows the entrance to the lift connecting the Rocket House Pleasure Gardens with the Rocket House Café/Henry Blogg Museum building.

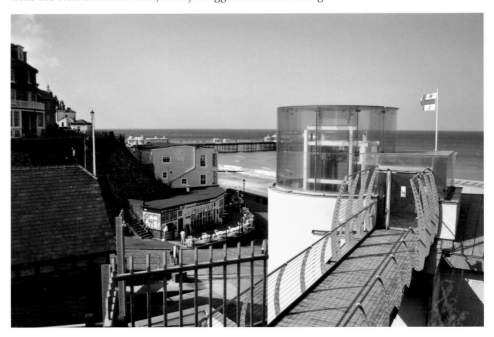

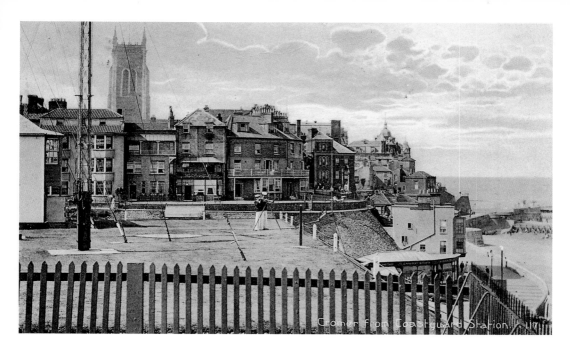

The Old Coastguard Station

The Coastguard Station was located in the house formerly known as Webbs House, next to what is now the Rocket House Pleasure Gardens, until 1927 when it moved to the Marrams, Runton Road. Two hundred years ago the lawn seen here extended further seawards and was used as a bowling green.

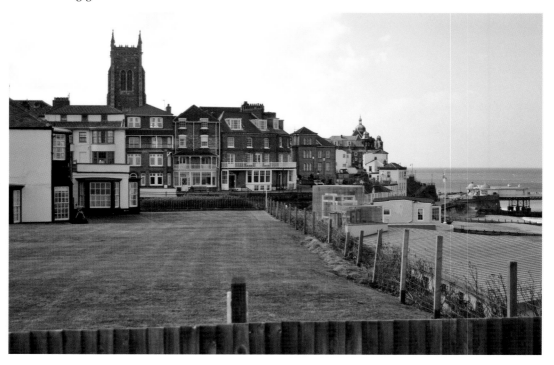

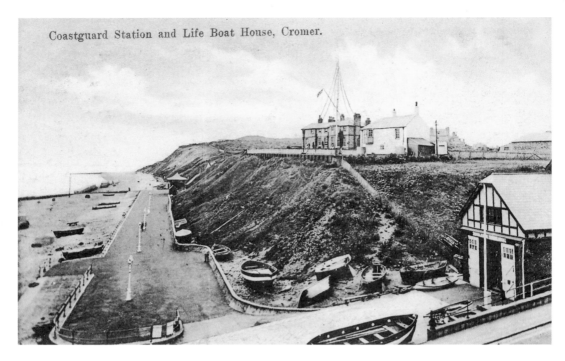

Coastguard Station and Life Boat House, Cromer.

Old Coastguard Station and Lifeboat House

The area at the base of the cliff to the left of the Lifeboat House in the earlier picture, containing several crab boats, was used to stable bathing machines in the 1920s, before the construction of Joyce's Café. This was destroyed by the first bombing raid on Cromer on 11 July 1940, but a café was rebuilt here after the war, which was removed before the construction of the Rocket House/Henry Blogg Museum building.

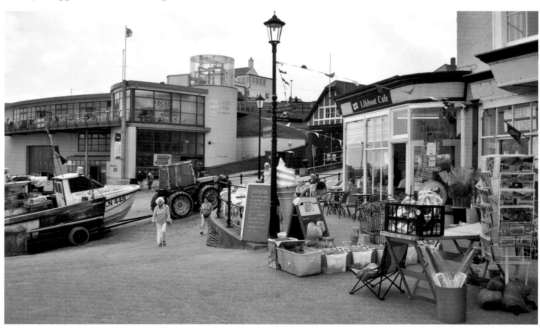

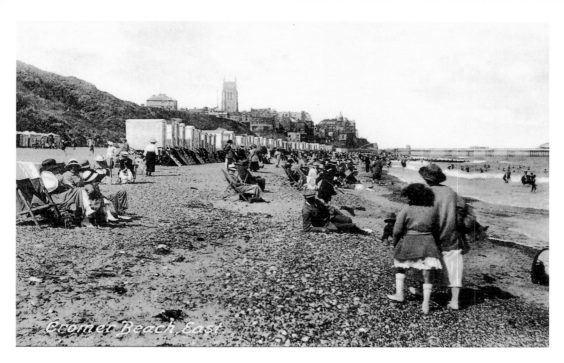

East Beach

The East Beach, looking westwards. By the 1930s, the bathing machines were no longer drawn forward to the water's edge, but were kept at the top of the beach and used as beach huts.

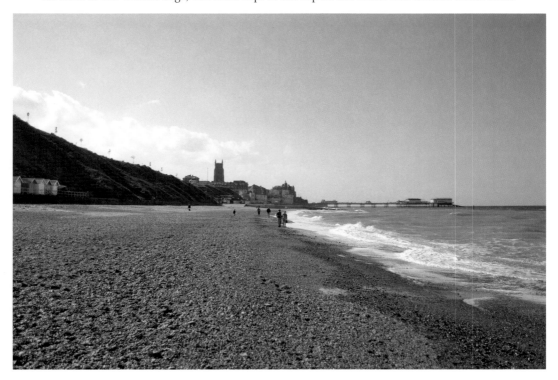

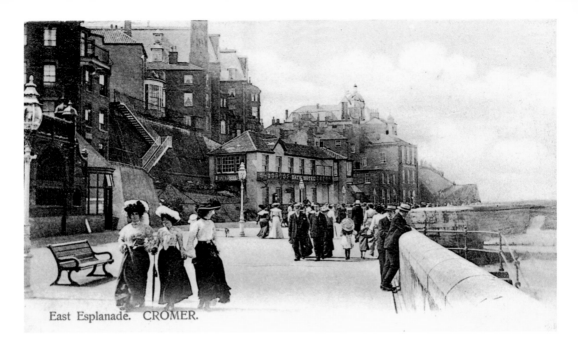

East Esplanade. CROMER.

East Esplanade

After some successful years in the late twentieth century, during which it made appearances in the *Good Beer Guide*, the Bath Hotel (originally the baths of Simeon Simon in the early nineteenth century) has been closed in recent years, but hopes remain that it may reopen. The contemporary view is partly obscured by the lifeguards' hut which is manned throughout the summer season.

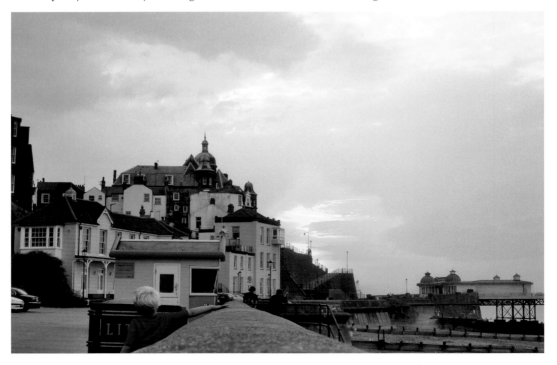

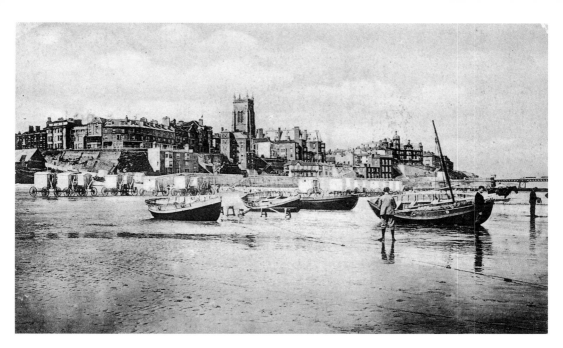

East Beach at Low Tide

These two views across the East Beach with the tide out, taken a century apart show that although changes in detail have taken place, the essential charm of Cromer's sea front remains unspoilt.

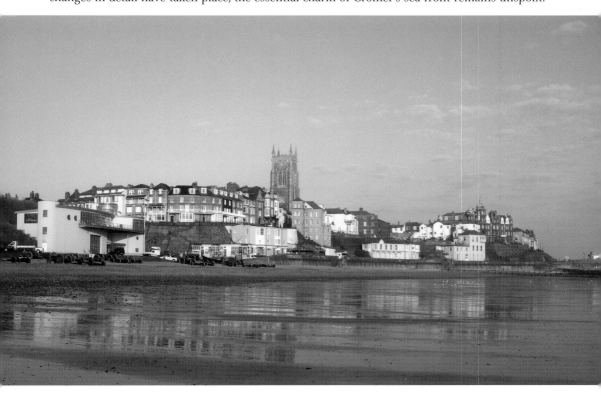

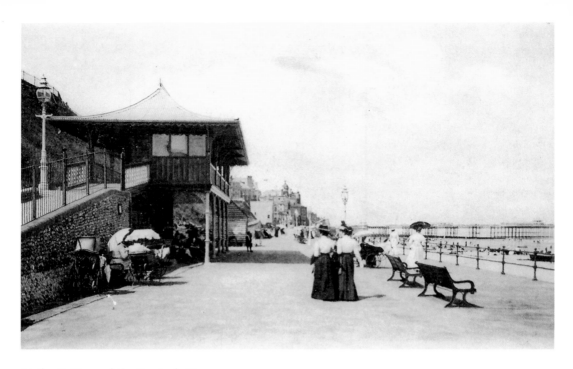

At the Bottom of the Doctor's Steps
Named after Dr Sidney Terry, the Doctor's Steps provide access from the cliff top to the eastern end of the promenade. The shelter at their bottom has undergone some changes since the early 1900s, most notably a new roof, but the basic structure has survived well.

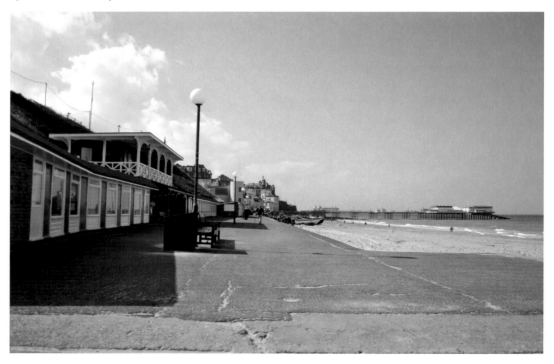

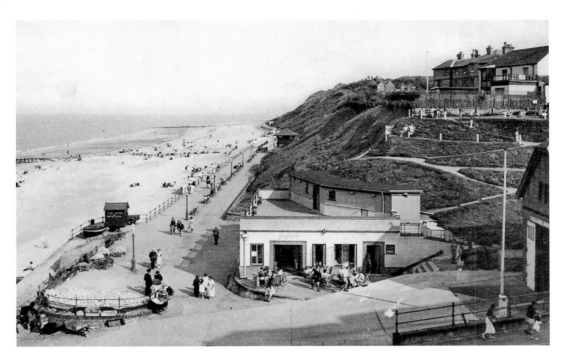

East Beach Looking East
The early view shows the post-war café at the bottom of The Gangway. As recently as 1983, a roast beef lunch could be had here for £1.40.

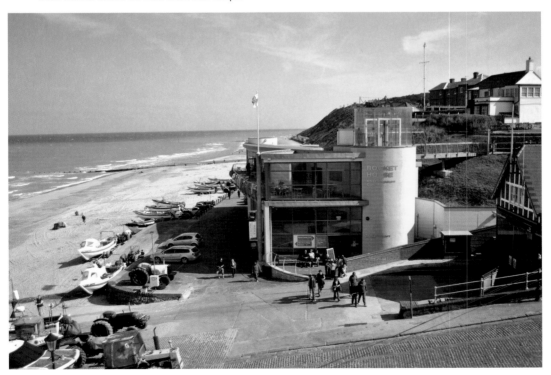

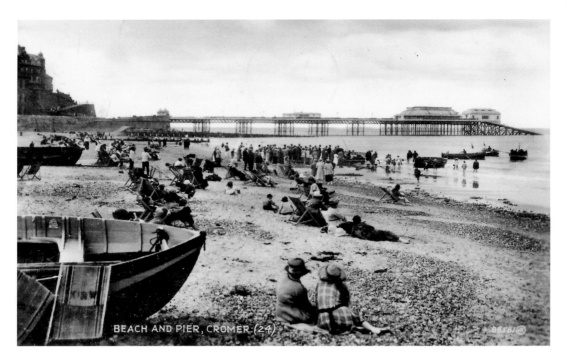

BEACH AND PIER, CROMER. (24)

East Beach and Pier

A crowd gathers around a pleasure craft on the East Beach between the wars in the earlier photograph. Today's view illustrates the tractors that have consigned the arduous manual launching of crab boats into the sea to history.

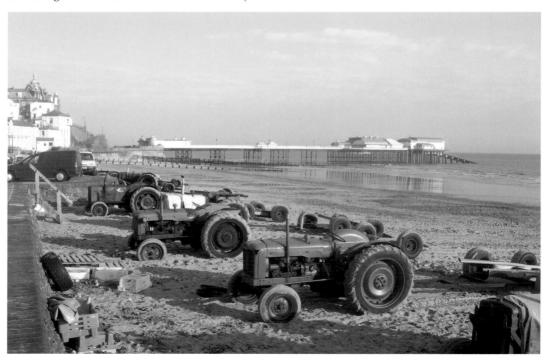

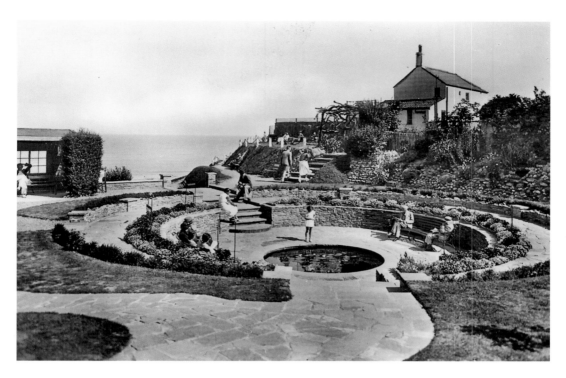

Rocket House Pleasure Gardens Looking East
The Rocket House Gardens showing the former Coastguard Station, built by master mariner Alexander Webb.

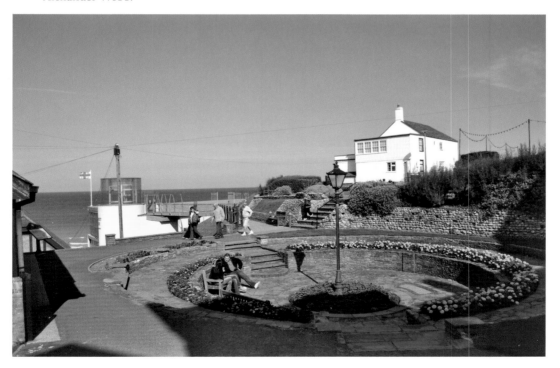

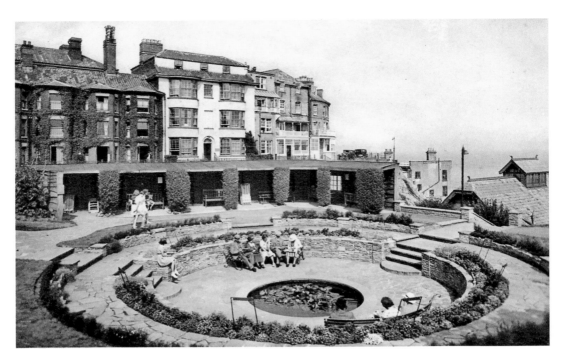

Rocket House Pleasure Gardens Looking West
The Rocket House Pleasure Gardens with Brunswick Terrance (left) and Brunswick House (centre) in the background. The hipped-roofed house just before the start of the Crescent was the Little Tuckers Hotel in the 1980s.

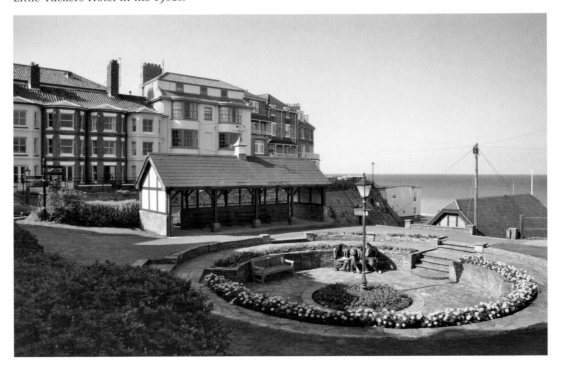

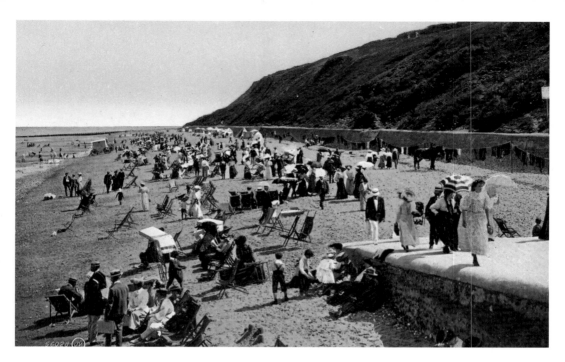

East Beach Looking Towards the Lighthouse Cliffs
The view from the eastern end of the promenade. A concrete wall does extend further towards Overstrand for some distance, before the cliffs become undefended below the course of the Royal Cromer Golf Club.

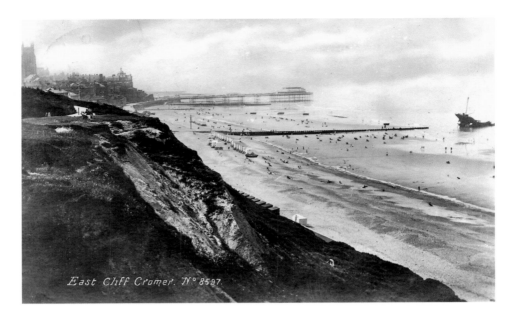

East Cliff Cromer. N.° 8597.

East Cliffs Looking West

The earlier view looking west from the East Cliff shows the wreck of the *Fernebo*, which rested on the East Beach between 1917 and 1923 (at exceptionally low tides some remains of it are exposed even today). The story of the *Fernebo* exemplifies the outstanding bravery of the Cromer lifeboatmen, led for thirty-eight years by the legendary coxswain Henry Blogg, whose bust stands outside North Lodge (inset). In January 1917 the Cromer lifeboat had been at sea for 3½ hours rescuing sixteen crew from a Greek steamer when an explosion on the Swedish *Fernebo* broke the vessel in two. One half came to rest on the beach, the other was grounded a mile out to sea. Under Blogg, the lifeboat was successful in reaching the further half of the *Fernebo* on its fourth launch into the sea that day, and after battling the sea for 14 hours, the eleven crew stranded were brought safely to shore.

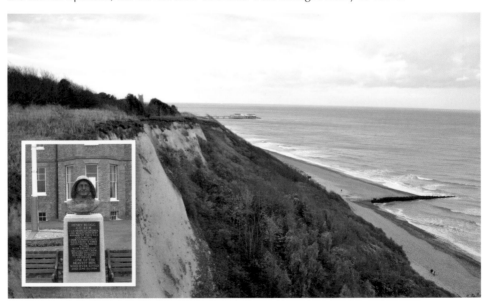

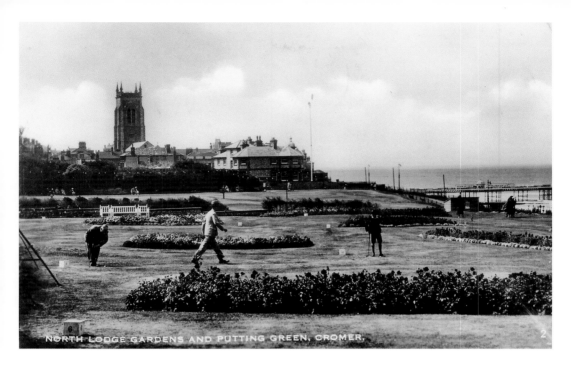

NORTH LODGE GARDENS AND PUTTING GREEN, CROMER.

North Lodge Putting Greens

While the Royal Cromer Golf Club is the most famous of the town's golfing connections, the town is liberally provided with putting greens, at the Meadow, on the West Cliff and here at North Lodge.

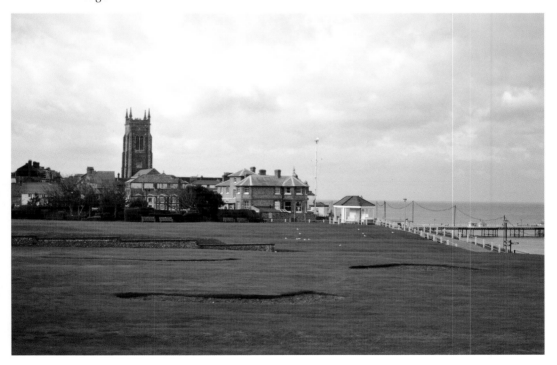

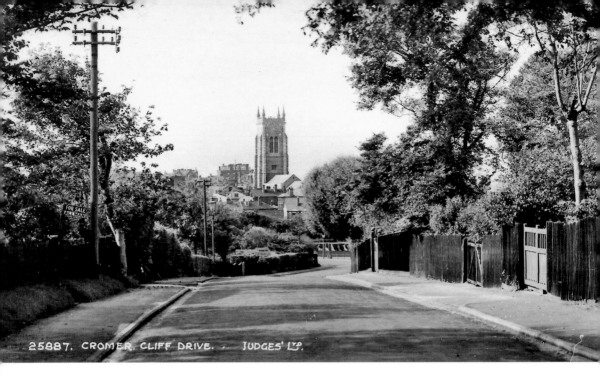

Cliff Drive

In the twentieth century Cromer expanded along the East Cliffs towards Warren Woods with the construction of Cliff Drive. As ever, the tower of Cromer Church dominates the scene.

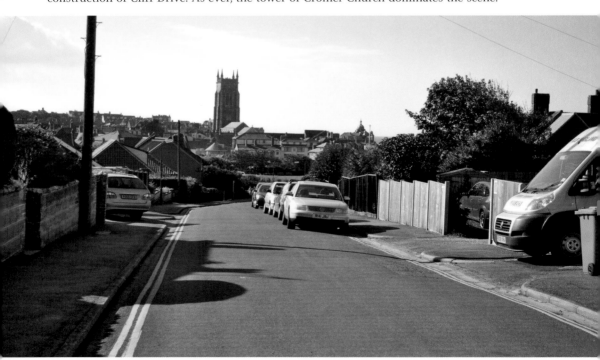

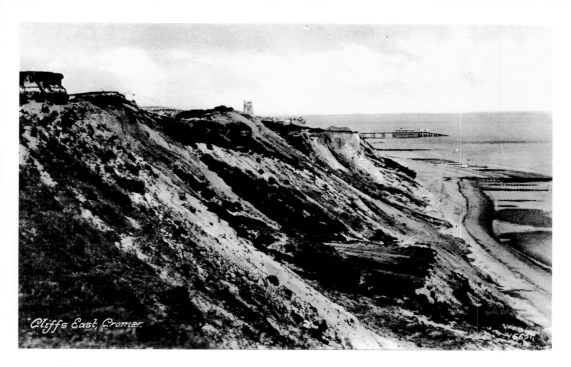

Cliffs East

To the east of Cromer, the cliffs rise to a height of 250 feet above sea level. There have been many cliff falls here over the years, the largest recorded being in on 15 January 1825 when 12 acres of land were lost. In the earlier view a section of level ground is seen intact near the base of the cliff, having slid downwards.

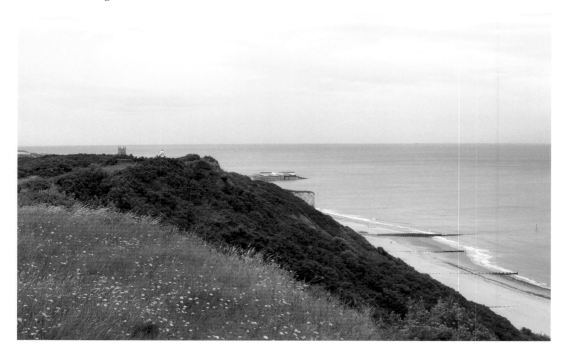

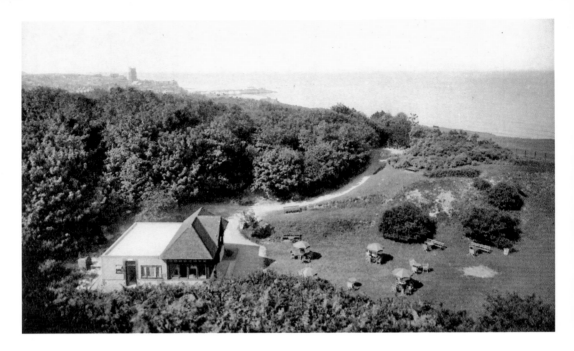

Warren Woods

Warren Woods lie just over half a mile east from the pier, and in the nineteenth century were the location of a limeworks. A café was opened here between the wars, but did not reappear after the Second World War. Today, the water pipe which supplied it can still be found running through the trees, and the site it occupied is open grassland. Both views are taken from the high ground on which the lighthouse stands; the Links Woods in the foreground (along the Elizabeth Fry Walk from Overstrand Road) have grown considerably in the intervening years.

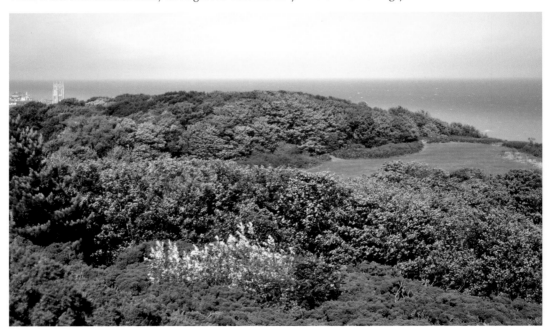

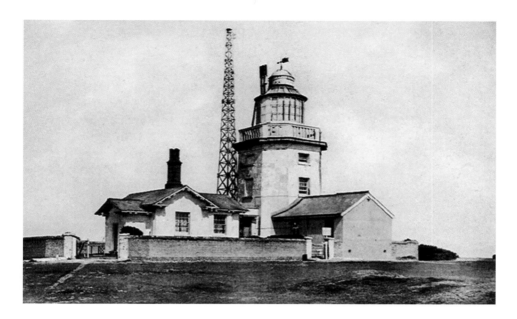

The Lighthouse

Lights to warn mariners away from the treacherous coast off Cromer were first lit on the tower of Cromer Church, but from 1669 a lighthouse was provided on the high cliffs to the east of the town. In 1832 a large section of cliff close to the lighthouse was washed away, and so a replacement 250 yards inland was built the following year. This 52-foot-high lighthouse has been in use ever since. The early view shows the original small cottage provided for the lighthouse keeper. In the twentieth century the accommodation was increased to two houses which, since the lighthouse became automated in 1990, have been let out by Trinity House to holidaymakers.

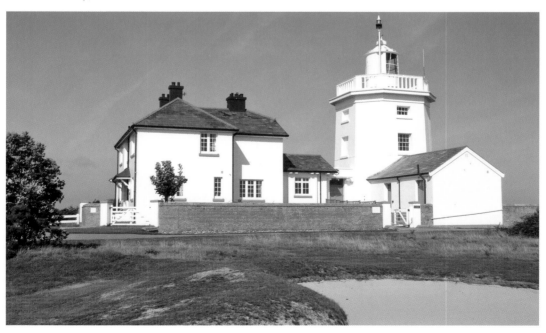

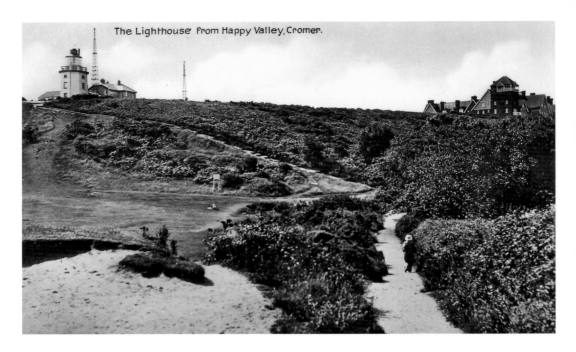

The Lighthouse from Happy Valley, Cromer.

The Lighthouse and Happy Valley

Happy Valley, a shallow gorge, lies between the lighthouse and the edge of the cliffs. Although the lighthouse stands on the highest piece of ground, it had a nearby rival on the skyline for fifty-five years at 52 foot high – the Royal Links Hotel. This building is seen peeping over the hill in the earlier view across Happy Valley. The hotel burnt down in 1949; today the roofs of the villas of Cromer Country Club can be seen to the west of the lighthouse.

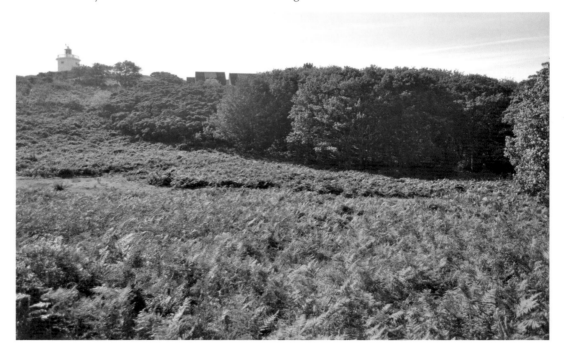

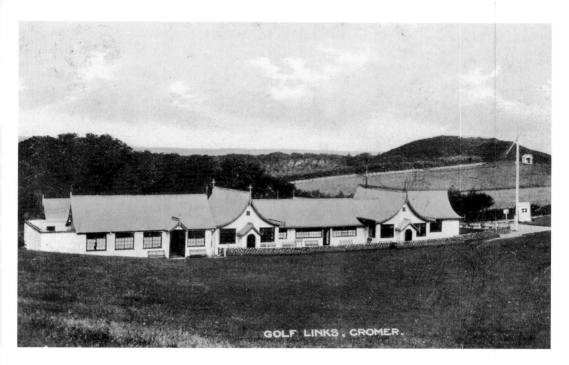

GOLF LINKS, CROMER.

Happy Valley Looking West

In 1887 Happy Valley became the location for the Royal Cromer Golf Club. Beginning with a nine-hole course, the clubhouse was built of corrugated iron and was second-hand at least in part, having reputedly been previously used as a butcher's shop in the town.

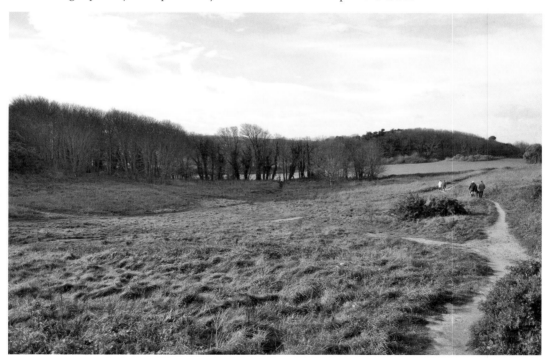

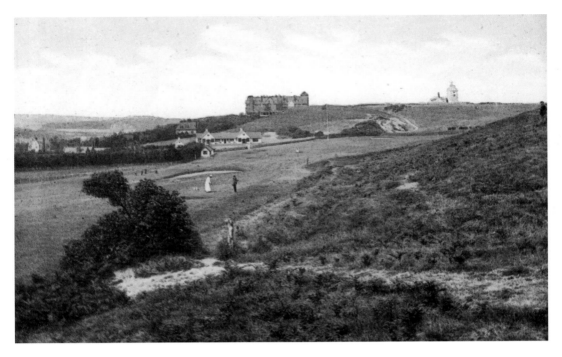

The Royal Cromer Golf Club
The golf club soon extended its course and a new clubhouse was built to the south-east of Happy valley. The earlier, 1930s, view shows the clubhouse with the Royal Links Hotel looming in the background.

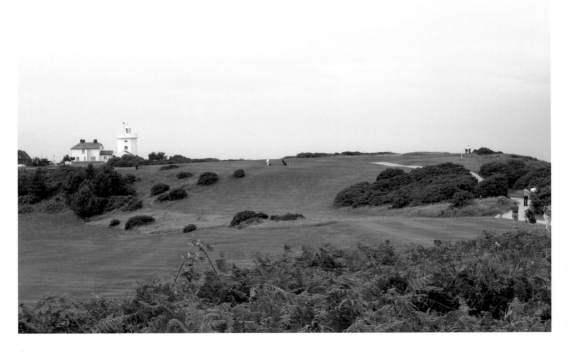

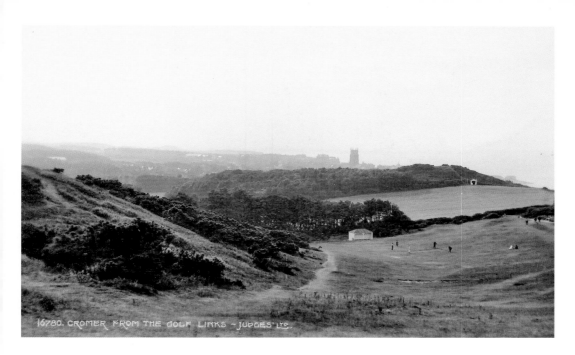

16780. CROMER FROM THE GOLF LINKS - JUDGES' ltd.

Happy Valley

The old clubhouse was replaced with a small shelter along the path that is now the Elizabeth Fry Walk and in time, the Happy Valley section of the golf course was abandoned. Today it is being reclaimed by nature but still provides a very attractive place to walk.

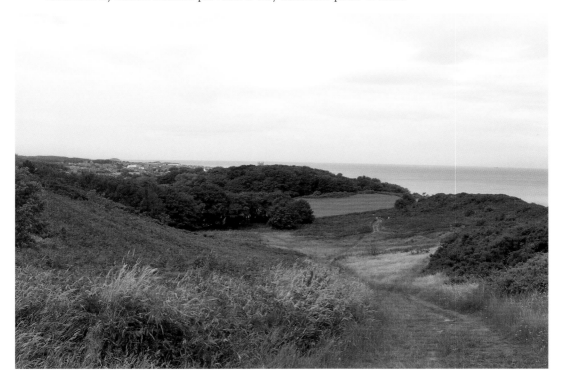

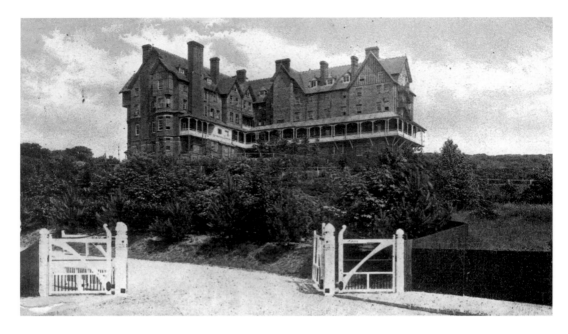

Royal Links Hotel

Constructed in 1894, the Royal Links Hotel was patronised by the Prince of Wales, later Edward VII, and was the most ambitious of Cromer's hotels. The early view shows it from the Overstrand Road; used by the military during the Second World War, it never reopened. Its foundations are today the base for the buildings of the Cromer Country Club, which used the hotel's pavilion until 1978, when, like the hotel before it, the pavilion burnt down.

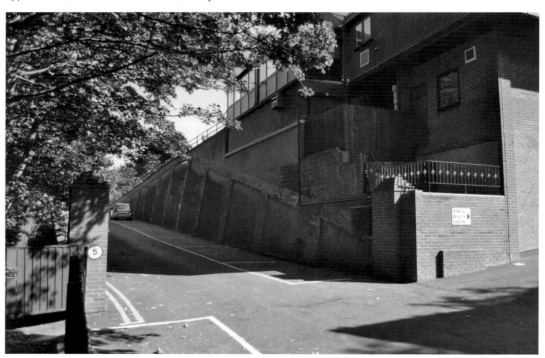

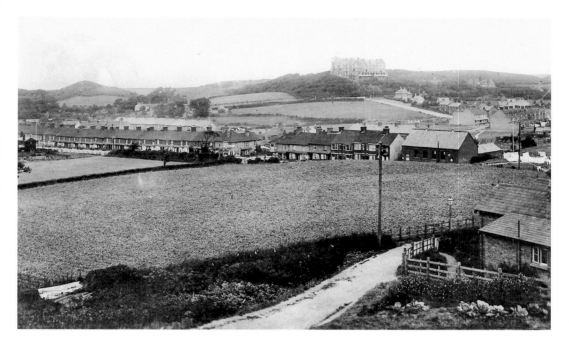

Links Hotel from Cromer High
The area between Cromer High Station and the Overstrand Road is known as Suffield Park after landowner Lord Suffield. The Royal Links dominates the earlier view; its contribution to the landscape was not universally admired.

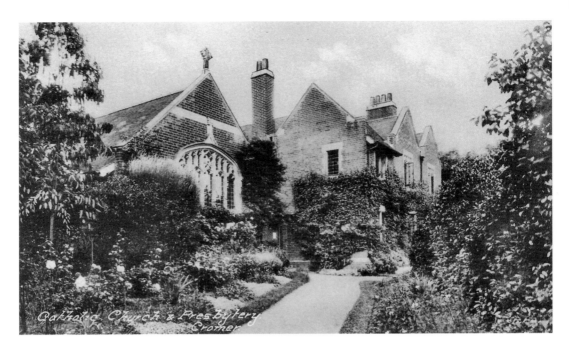

Catholic Church & Presbytery Cromer

The Catholic Church

In 1896 the area around the lighthouse and the golf club, which had been part of Overstrand parish, was transferred to Cromer. In that year, the Roman Catholic Church, dedicated to Our Lady of Refuge, was built. It is the last building in Cromer on the road to Overstrand. A new hall was added in the 1990s.

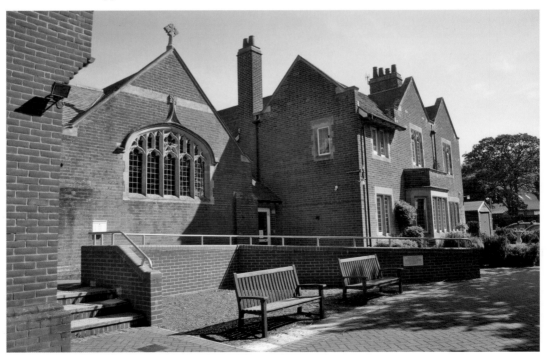

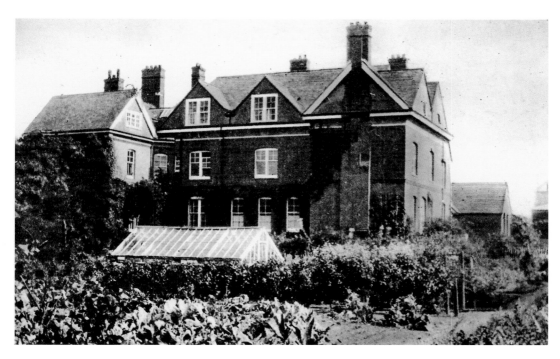

Links Side
The Suffield Park area of Cromer comprised mainly of large villas rather than commercial hotels. Links Side, however, in Park Road, functioned as a guesthouse for the Holiday Fellowship for many years.

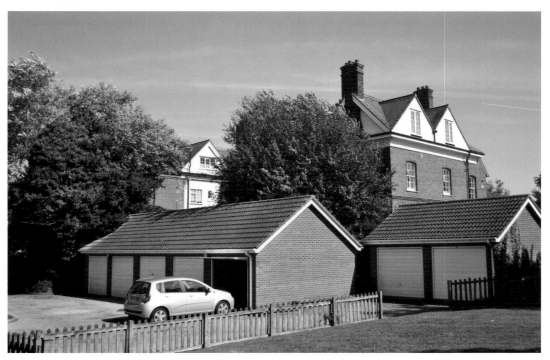

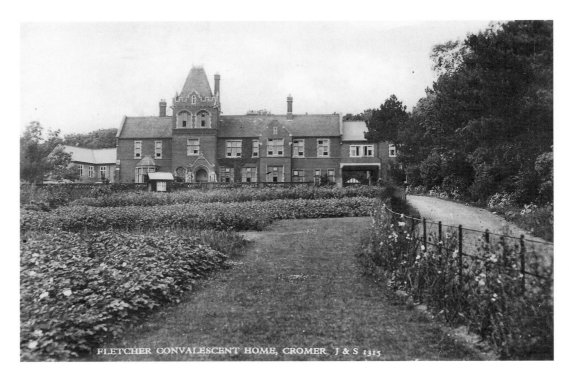

FLETCHER CONVALESCENT HOME, CROMER J & S 1315

Fletcher Convalescent Home

The Fletcher Convalescent Home was completed in 1893 in the domestic Gothic style on a 3-acre site off the Norwich Road as the gift of B. Edgington-Fletcher of Marlingford Hall, Norwich, for patients from the Norfolk and Norwich Hospital. Today the ground between Norwich Road and the home is occupied by the Benjamin Court sheltered housing complex.

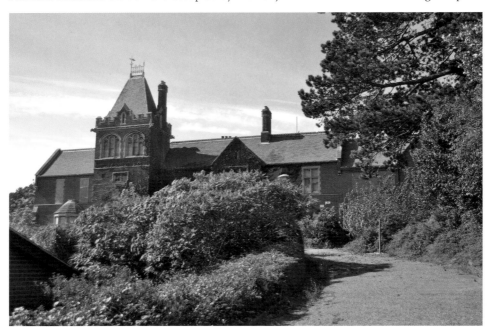

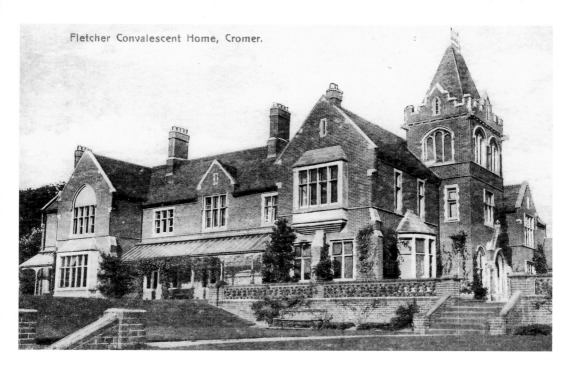

Fletcher Convalescent Home, Cromer.

The Fletcher Home South-East Corner

The Fletcher Home was latterly under the aegis of Cromer Hospital as a geriatric unit and closed in 1998. Since then it has lain derelict while subject to a number of planning applications and in 2008 was placed in the Victorian Society's Top Ten Endangered Buildings list. Here the south corner of the building is seen disappearing under foliage.

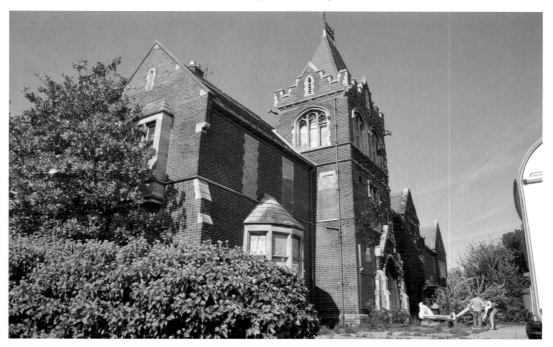

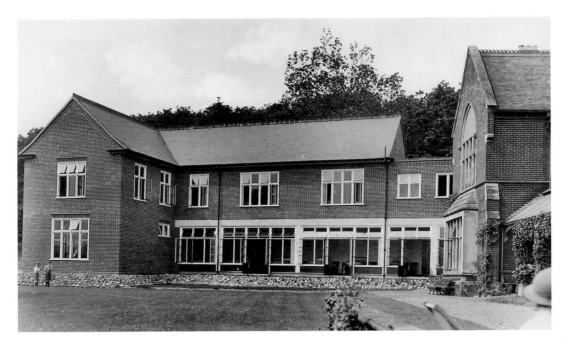

The Fletcher Home Children's Wing

The original building, designed by Boardman & Son of Norwich, was augmented in the twentieth century with the addition of a children's wing. Twelve years after the home's last use, it has been sold to developers for conversion to housing, but a requirement for some of the accommodation to be for affordable housing has delayed the commencement of work, while the children's wing disappears from view.

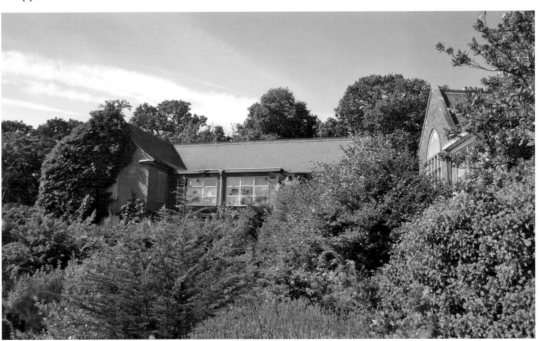

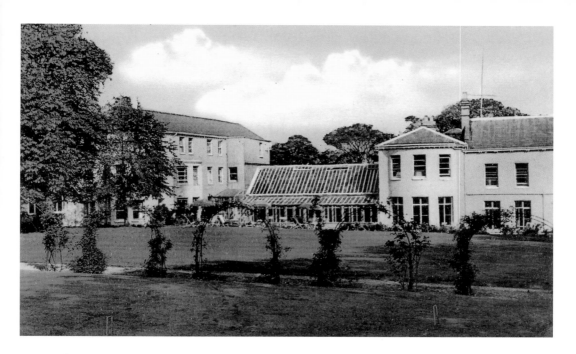

Colne House

In the nineteenth century Colne House was the residence of Sir Thomas Fowell Buxton, the owner of the major London brewery of Truman Hanbury, Buxton & Co. He found lasting fame when, during his time as an MP, he took over leadership of the campaign against slavery in the years after trade in slaves had been outlawed, but slavery itself persisted. In 1833 his aim was achieved and slavery was officially abolished throughout the British Empire. For a forty-year period until the 1970s, Colne House was a hotel, before being divided up into apartments.

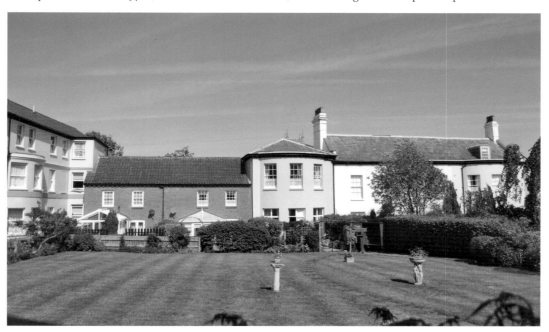

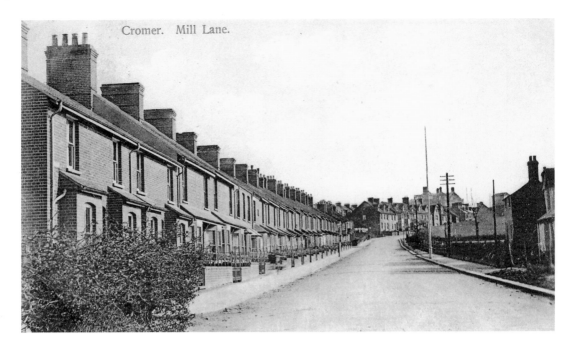

Cromer. Mill Lane.

Mill Road

The high ground which would become the site of Cromer High railway station was the location of a windmill in the eighteenth century, giving the road leading there from the town its name. In the earlier view, the outline of the Suffield Park Hotel, which stood opposite the station, can be seen on the skyline. The hotel was converted to flats in the 1990s, leaving this area of Cromer without a pub.

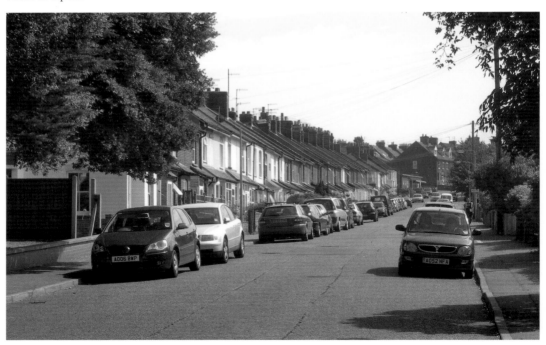

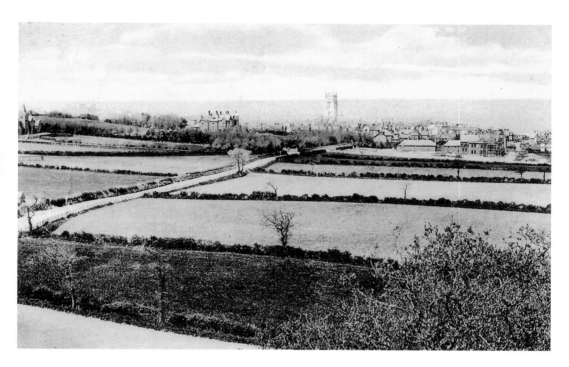

The View from Cromer High

The earlier view from Cromer High railway station illustrates its distance from the town. The large house with cupola in the middle distance to the left of the church tower was Newhaven Court, the home of Commander Oliver Locker Lampson. A hotel in the 1930s, guests here included the King of Greece and Prince Philip, Duke of Edinburgh, when he was a teenager. The Newhaven Court Hotel burnt down in 1963. The current view from Cromer High features Cromer Secondary Modern School, now Cromer High School.

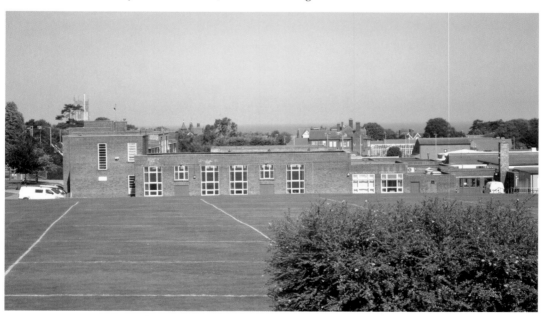

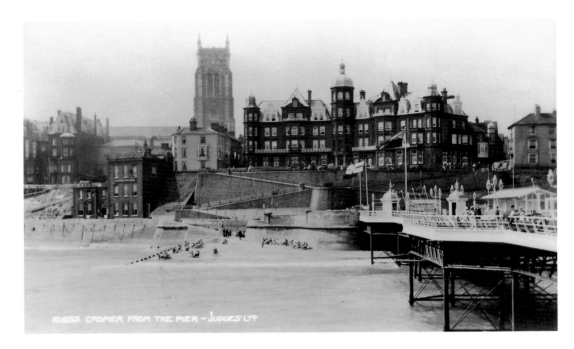

The Hotel de Paris

Six hundred years after it developed as a town around the Church of St Peter & St Paul and two hundred and twenty-five years after it first became a destination for holidaymakers, Cromer remains an enchanting town, truly deserving of the title 'Gem of the North Norfolk Coast'. There are many images that sum up Cromer, but the view of the town from the pier featuring the church tower and the magnificent Hotel de Paris probably illustrates the town best.

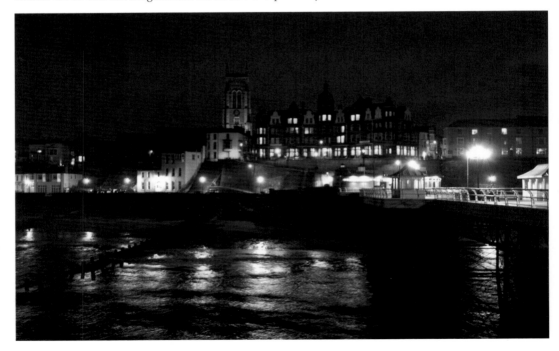